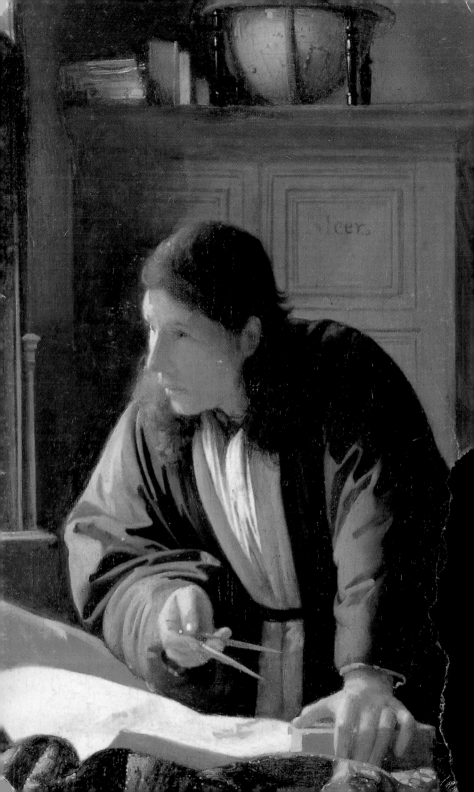

ArtBook
Vermeer

DORLING KINDERSLEY
London • New York • Sydney
www.dk.com

Contents

How to use this book

This series presents both the life and works of each artist within the cultural, social, and political context of their time. To make the books easy to consult, they are divided into three areas, which are identifiable by side bands: yellow for the pages devoted to the life and works of the artist, light blue for the historical and cultural background, and pink for the analysis of major works. Each spread focuses on a specific theme, with an introductory text and several annotated illustrations. The index section is also illustrated and gives background information on key figures and the location of the artist's works.

1632–1656

1656–1665

■ Page 2: Vermeer, *The Geographer*, detail, Städelsches Kunstinstitut, Frankfurt.

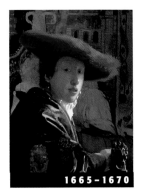

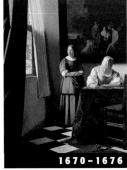

1665-1670

1670-1676

Index & Biography

Vermeer's ascendancy

The final years

From inn-keeper
to master painter

Delft, at the heart of Holland

▼ Master of the Virgo Inter Virgines, *Madonna among the Virgins*, 1490, Rijksmuseum, Amsterdam. The artist who painted this work is Delft's most important 15th-century painter. An artist of consummate delicacy and elegance, he drew on the refined style of Flemish painters, adding an intimate touch and a sense of tranquillity. This warmth of feeling had a lasting impact in the city's artistic memory.

Situated just a few miles from The Hague, on the canal that branches off from the Rhine at Rotterdam and flows into the Zuiderzee, Delft was one of the most flourishing centers of the former United Provinces. Its present-day atmosphere of tranquillity makes it difficult to imagine the city in the 17th century, when it was an animated and lively setting for countless manufacturing and commercial activities. Within the streets of the walled city, breweries and cloth factories thrived and the air was hot with the kilns of the highly prized ceramics that were exported throughout Europe and were the backbone of Delft's economy. It was a prosperous city, and an international trading center popular with a solid bourgeoisie that was well-disposed to the purchase of works of art. Delft was also the symbol of national independence, in that it had been the favored seat of the *stadhouder* William of Orange, known as William the Silent, hero of the revolt against Spanish sovereignty. The war against Spain was a protracted and grim conflict, begun in 1559, which not even the assassination of the *stadhouder* in 1584 had been able to stop. The United Provinces finally defeated the Spanish aggressor and Delft claimed a permanent place in the hearts of the Dutch people.

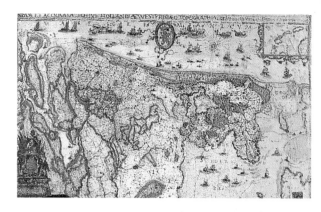

◄ Vermeer, *Soldier and Laughing Girl,* detail, Frick Collection, New York. Vermeer includes many peripheral details in his paintings, always rendering them with meticulous care. From the background of *Soldier and Laughing Girl,* this map of Holland is a good example, drawn, as was the custom of the time, with the West uppermost.

▶ Gerhard Houckgeest, *The Niewekerk at Delft with the Monument to William the Silent,* 1651, Mauritshuis, The Hague.

▼ Daniel Vosmaer, *View of Delft,* 1665, Museum "het Prinsenhof", Delft. A virtuoso display of perspectival skill, this painting is an evocative portrait of the city's windmills, monuments, and spires.

▼ Anthonis Mor, *Portrait of William the Silent,* 1555, Gemäldegalerie, Kassel. This lively portrait by the best Dutch portraitist of the 16th century captures the indomitable spirit of the Prince of Orange.

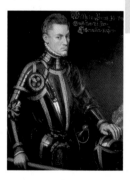

Windmills, spires, and a famous tomb

A tourist destination even in the 17th century, with people flocking to see the tomb of William the Silent built by Hendryck de Keyser, Delft is one of Holland's best-loved and most frequently visited cities, perfectly preserved within its dense network of canals and fortifications. Peaceful windmills and neat rows of houses alternate with bridges, prestigious buildings, and monuments, with the wide urban space of the central square at the heart of the city. Dominating the view are the tall and intricate Gothic spires of the two main churches, known simply as "Old church" and "New church"; both are important examples of Dutch Gothic, with the Baroque turret of the town hall nestling between them.

The Flying Fox and Mechelen inns

In a commercial city, its layout arranged around the large market square and thronged with visitors paying homage to the memory of William the Silent, owning an inn was one of the most lucrative activities. In about 1630, Vermeer's father, Reynier Janszoon, who had started out as a weaver, decided to make an investment that would change his life: he rented the *de vliegende Vos* (The Flying Fox) inn, named after the surname by which he was commonly known. It was fortuitously located on the Voldersgracht, the canal close to the market square, in the town center. The venture was successful, and in 1631 Reynier's organizing of auctions and sales of paintings at the inn earned him membership of the Guild of St Luke as an art dealer (*Constverkoper*). Ten years later, he moved to another inn, on the market square itself, the "Mechelen", named after the Flemish city from which Vermeer's family originated.

▲ This engraving from 1710 shows us what Vermeer's father's Delft inn would have looked like. The inn included living quarters for the family.

▼ Jan Steen, *The Card-Players*, c.1660, Private Collection. This magnificent painting, which has become known only recently, shows the interior of a typical 17th-century inn, where customers could play cards, drink, smoke, and be entertained.

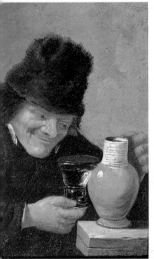

▲ David Teniers the Younger, *Old Drinker*, c.1640, Musei Civici, Brescia, Italy. Flemish and Dutch art abounds with portraits of inn drinkers.

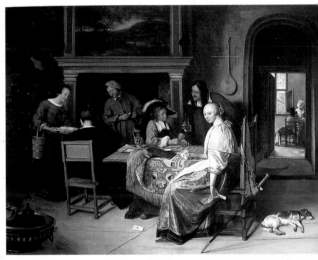

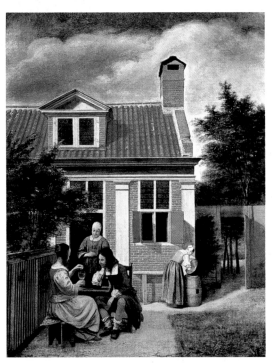

◀ Pieter de Hooch, *Country House*, c.1665, Rijksmuseum, Amsterdam. De Hooch provides us with a comforting picture of everyday life, with a characteristic atmosphere of serenity and tranquillity.

▼ Vermeer, *The Glass of Wine*, c.1662, Staatliche Museen, Berlin. Vermeer's paintings are almost always set in clean bourgeois interiors rather than public places such as inns. Nevertheless, he reveals himself to be a consistently sharp observer of gestures, looks, and domestic situations. Behind the banal act of pouring a glass of wine lies a subtle wealth of references and feelings.

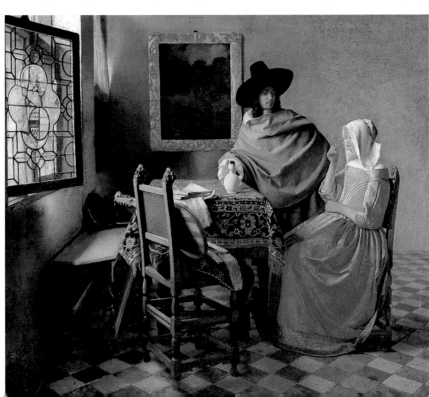

BACKGROUND

Dutch art in the mid-17th century

The flowering of Dutch painting in the 17th century is one of the most remarkable chapters in the entire history of art. This young country suddenly discovered a vocation that had no particularly strong precedent in the previous centuries. During the so-called Golden Age, the Dutch produced and purchased more paintings per capita than any other country. Most of these works were destined for private collections: there was no call for religious art (the Calvinists had banned the display of paintings or frescoes in churches), and so, excepting works commissioned by guilds of civic associations, Holland's artistic output was aimed at the well-tended, comfortable homes of the affluent classes. Dutch 17th-century art is therefore characterized by themes and formats compatible with interior decoration: the most common subjects were scenes drawn from everyday life — landscapes, portraits, and still lifes, all painted on small or medium-sized canvases. Mythological, symbolic, or literary themes were rather rarer, commissioned by intellectual patrons and executed in competition with imported Italian works of art.

▲ Frans Hals, *Smiling Boy*, c.1627, Mauritshuis, The Hague. During his long career, Frans Hals established himself as the liveliest portrait painter of his day. This painting belongs to a group of works that were not commissioned by individual patrons and in which the artist depicted everyday subjects.

▼ Emmanuel de Witte, *The Oude Kerk, Amsterdam*, 1659, Kunsthalle, Hamburg. Luminous church interiors were very popular. De Witte and Saenredam were the main artists to favor this theme.

▲ Nicolaes Maes, *Girl at a Window*, c.1655, Rijksmuseum, Amsterdam. Dutch art of this period abounds with intimate, lyrical scenes such as this.

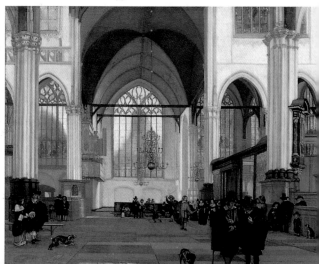

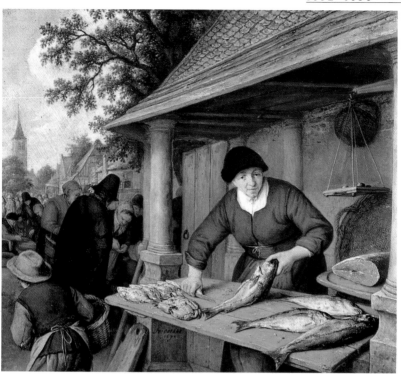

▲ Adriaen van Ostade, *The Fish Seller*, 1672, Rijksmuseum, Amsterdam. Scenes from everyday life were very popular, embodied as they were with an underlying satisfaction in the nation's prosperity.

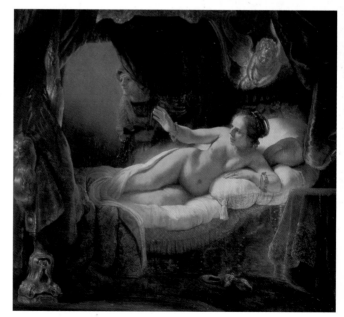

► Rembrandt, *Danaë*, 1636, with revisions in 1654, State Hermitage Museum, St Petersburg. Rembrandt, the greatest of all Dutch painters, painted in a style that was totally independent of the prevailing trend – of which he was occasionally critical.

Carel Fabritius
and the Delft School

While contributing to a cohesive and clearly identifiable national artistic movement, Holland's main cities nevertheless harbored local artists and schools of painting. Had Vermeer been born in another city, his development and style may have been substantially different. Delft stood apart from other cities in 17th-century Holland for a number of important reasons. Firstly, artists working in the city had a considerable interest in the study and application of perspective, taking it as far as optical illusion. Secondly, there was a considerable influx in the city of Italian works of art or works inspired by the great masters of the Renaissance and early Baroque. Finally, artists working in Delft favored the effects of light or color over rigidly precise draughtsmanship. All these elements can be found in the work of Carel Fabritius (1622–1654), the central figure of Delft's artistic scene during the mid-17th century. A pupil of Rembrandt, he was inspired by the master to use strong chiaroscuro contrasts and to apply color in large areas, with light effects superimposed on top. Fabritius, who had moved to Delft in the 1640s, soon proved to be an original artist able to produce unusual effects. His career was cut short by his premature death in the Delft gunpowder magazine explosion of 1654.

▼ Carel Fabritius, *A Young Man in a Fur Cap and a Cuirass (Self-Portrait?)*, 1654, National Gallery, London. The confident pose and the way in which the sitter, aged about 32, looks directly at the viewer, seem to justify the theory that this is a self-portrait.

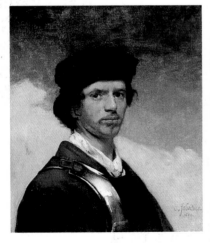

▼ Carel Fabritius, *Gentleman on Horseback*, c.1650, Accademia Carrara, Bergamo. Works by Fabritius are extremely rare and are usually small in size. They all display a vibrant originality.

▶ Carel Fabritius, *The Raising of Lazarus*, c.1640, Muzeum Narodowe, Warsaw. This youthful work, executed in Amsterdam while the artist was in close contact with Rembrandt, was inspired by one of the master's engravings.

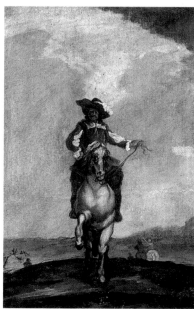

▶ Carel Fabritius, *The Goldfinch*, 1654, Mauritshuis, The Hague. This effective and pleasing *trompe l'oeil* was probably painted to decorate a birdhouse for a real goldfinch.

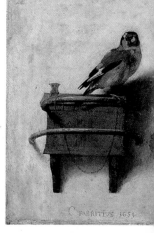

◀ Carel Fabritius, *View of Delft*, 1652, National Gallery, London. This painting reveals the artist's confident and highly original use of perspective.

Vermeer's early years

O n October 31, 1632, Johannes, son of Reynier Janszoon, known as "Vos", and Digna Baltens, was baptized in Delft's historic Nieuwe Kerk, close to the tomb of William the Silent. The boy grew up in the family inn, surrounded by paintings. His father's activities focused increasingly on dealing in works of art, particularly Italian paintings. Some attempts at reconstructing Reynier's art collections have been made, identifying some of the works that passed through his inn and were put up for sale. Piecing these works together, although a difficult job, has proved to be important in our understanding of the visual references available to the child Vermeer and, later, the apprentice painter. Interestingly, some of Vermeer's works include paintings within paintings, which frequently feature works that are either Italianate in feel or specifically identifiable as Italian. In the absence of documentation or any certain information as to Johannes Vermeer's artistic training, we have to conclude that his father's art dealing must have played a crucial role, together with the wide range of paintings, some imported and not always of top quality, to which he must have had access. His earliest known works reveal the influence of Italian models.

▶ Vermeer, *Diana and her Companions*, c.1655 Mauritshuis, The Hague. The only painting by Vermeer to have a mythological theme, this work is crucial to our understanding of the artist's youthful progression and the beginning of his career. It was painted shortly after his father's death in 1652, when Vermeer had just come of age. The delicate light, the relaxed classicism of the poses, and the colors recall the works of Correggio and Titian. The painting nevertheless reveals a wish to focus on an episode from everyday life, giving it an intimate, domestic dimension. The silence of the women and, most importantly, the delicate light in which the scene is bathed, would later develop into characteristic features of Vermeer's art.

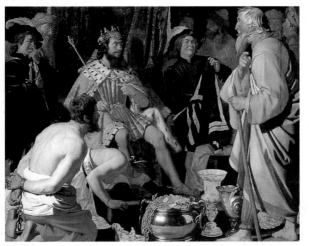

◀ Gerrit van Honthorst, *Solon and Croesus*, 1624, Kunsthalle, Hamburg. Active in Italy for a long time (where he was dubbed *Gherardo delle notti* – "Gerard of the Nocturnes" – because of his predilection for night scenes), van Honthorst played a fundamental role in introducing Caravaggesque models to Holland. His grandiose paintings were much in demand among collectors of the time.

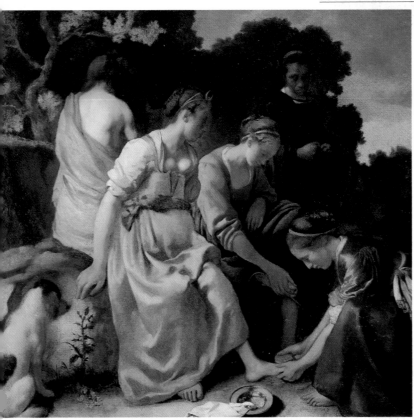

▼ Lucas van Leyden, *The Card Players*, c.1525, Thyssen Bornemisza Collection, Madrid. While it is important to stress the importance of Italian models in the early development of Vermeer's art, the traditions of Flemish and Dutch art also played a key role. Seemingly banal scenes such as this were often imbued with a powerfully introspective intensity.

▲ Caravaggio, *The Card Players*, Kimbell Art Museum, Fort Worth. Caravaggio's work, in all its different phases and moods (from genre realism to religious paintings), soon dictated the common language of all European painting in the 17th century.

Sales, auctions, and exhibitions

V ermeer's father is an interesting figure, not only because he encouraged his son to become a painter but also for what his activities tell of us of the trade in works of art in mid-17th century Holland. In 1640, when Vermeer was just eight years old, Reynier signed a document using the surname Vermeer, which would later also be adopted by his son. Contrary to what might be supposed, his dual professions of art dealing, which granted him the membership of the appropriate guild, and inn-keeping were far from incompatible. Only a few major antiquarians owned proper galleries in which to hang works of art for sale. Exhibitions, sales, and auctions were usually held in taverns and hotels. A typical example of this is the auction of Rembrandt's chattels, necessitated by his severe financial embarrassment; this was held in an Amsterdam hotel, The Imperial Crown. The triumphs and disasters of Rembrandt's life tell us much about the customs of the art world in this era, including the evolution of the relationship between artist and dealer or collector, and the emergence of art cataloguing systems.

▲ David Teniers the Younger, *Self-portrait as Allegory of Sight*, c.1630, Akademie der Bildenden Künste, Vienna. Artists in the Netherlands often worked in shared studios or in large workshops run by a master painter.

▼ Jan Brueghel the Elder ("Velvet" Brueghel) and Peter Paul Rubens, *Allegory of Sight and Smell*, 1617, Museo del Prado, Madrid. Baroque painting has left us a number of delightful impressions of the jumbled displays of works of art acquired by "encyclopedic" collectors.

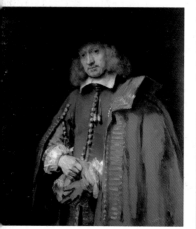

▲ Rembrandt, *Portrait of Jan Six*, 1654, Six Collection, Amsterdam, A discerning and notable collector, Six compiled the first catalogue of Rembrandt prints.

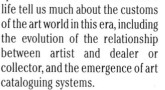

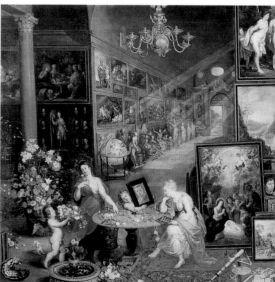

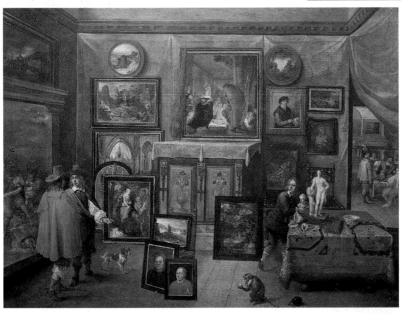

▲ Painted in about 1645, this work by Frans Francken and David Teniers the Younger (Courtauld Gallery, London) may depict antiquarian Pieter Stevens' gallery of paintings.

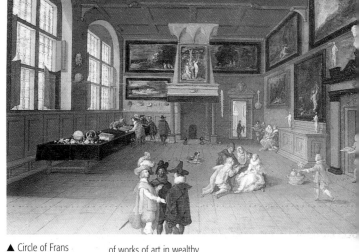

▲ Circle of Frans Francken II, *Interior with Figures*, c.1640, Sforza Castle, Milan. The overcrowded appearance of 17th-century art galleries was partly emulated by displays of works of art in wealthy homes, with objects displayed randomly, paintings hanging on the walls in rows, and larger decorative canvases positioned above the ubiquitous fireplaces.

1632–1656

Christ in the House of Martha and Mary

Painted in about 1655 and now housed in the National Gallery of Scotland, Edinburgh, this is a rare example of a religious subject by Vermeer.

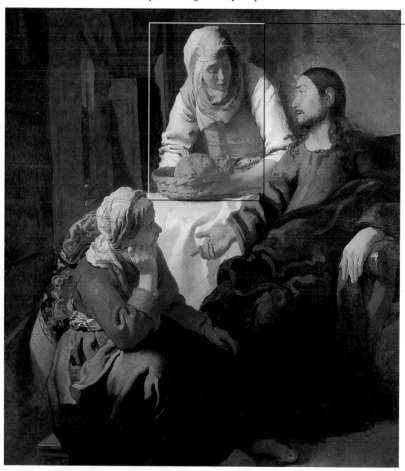

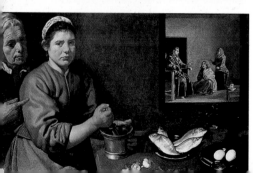

◄ Diego Velázquez, *Kitchen Scene with Christ in the House of Martha and Mary*, National Gallery, London. The Spanish master Velázquez also interpreted this theme as a genre scene and, unusually, presented it as a painting within a painting, hanging in the background on a kitchen wall.

◀ According to the Bible, Martha represents "active life" as opposed to Mary's more "contemplative" life. In the 17th century, this biblical episode was frequently illustrated with contemporary interiors and clothing. Vermeer's painting follows this trend, but introduces a poetic note of human feeling.

▼ Peter Paul Rubens and Jan Brueghel the Elder ("Velvet Brueghel") *Christ in the House of Martha and Mary*, National Gallery of Ireland, Dublin. The theme of Christ's visit to the sisters of Lazarus was very popular in 17th-century art. Here, with undeniable virtuosity, these two great artists alternate in the execution of figures and sections of still life.

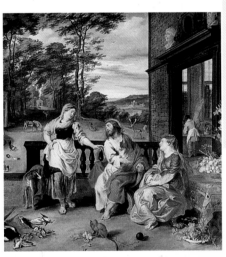

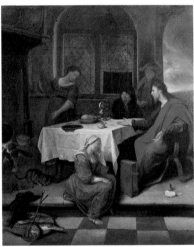

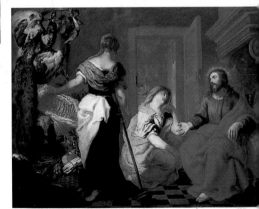

▲ Jan Steen, *Christ in the House of Martha and Mary*, Private Collection, Nijmegen. Dutch artists who painted this theme emphasized the domestic aspects of the episode by showing Martha bustling about with the implements of housewifery.

▶ Erasmus Quellinus, *Christ in the House of Martha and Mary*, Musée des Beaux-Arts, Valenciennes. Executed in Antwerp and featuring a more classical atmosphere, this painting may have inspired Vermeer.

LIFE AND WORKS

An opposed marriage

Little is known of Johannes Vermeer's life up to the age of 20. We can assume that the young Johannes must have helped his father Reynier in the buying and selling of paintings, an activity that the artist continued to pursue after his father's death in 1652. Johannes had just turned 20 and from this moment on had to act independently. In 1653, he made two important choices: to become a painter and to marry Catharina Bolnes. Both decisions were problematical: his work as an artist would not be lucrative enough for him to support a family (and would in any case have to be combined with his activity as an art dealer) and the bride's family opposed the marriage. Catharina lived with her authoritarian mother, the 60-year-old Maria Thyns, who had separated from her husband Reynier Bolnes more than ten years previously. Vermeer's future mother-in-law refused to give her signature in consent to the marriage, despite the insistence of two respectable witnesses, Captain Bartholomeus Melling and the painter Leonard Bramer. Against her wishes, Vermeer and Catharina were married on April 20 in the little church of Schipluiden, a village near Delft.

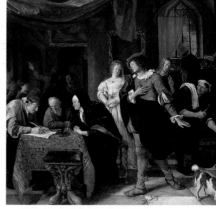

▼ Jan Steen, *The Marriage of Sarah and Tobias*, 1668–1670, Herzog Anton Ulrich Museum, Brunswick. This painting is a faithful portrayal of a typical marriage ceremony in 17th-century Holland, with the parents carefully checking the clauses in the nuptial contract.

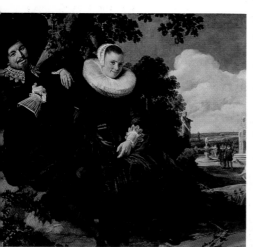

◄ Frans Hals, *Isaac Massa and his Wife*, 1622, Rijksmuseum, Amsterdam. This depiction of a happy married couple is one of the finest of its kind from the early 17th-century.

▶ Vermeer, *Portrait of a Young Woman*, 1666, Metropolitan Museum of Art, New York. Vermeer's portraits of women have given rise to much speculation as to the identity of the sitters. There is no definite information as to who these women actually were, and their anonymity remains a source of unending fascination. Since they are outside any concrete biographical context, they become symbols of a feminine ideal. The unnatural shoulder and arm joint, however, suggests that Vermeer may have used a manikin here.

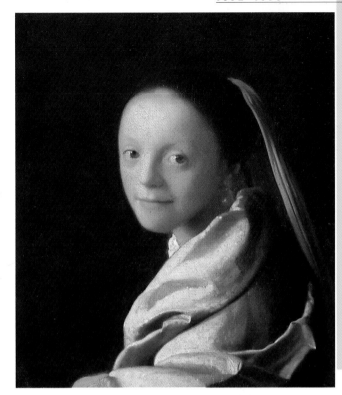

▼ Rembrandt, *Self-portrait with Saskia*, 1636, engraving.

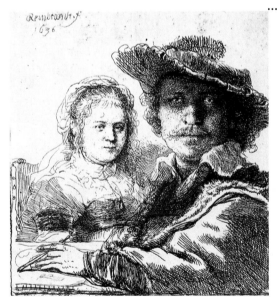

Rembrandt and Saskia, a marriage in pictures

Like Vermeer and Catharina, who encountered opposition to their proposed marriage, Rembrandt had to overcome the hostility of some of his betrothed's relatives in order to win Saskia's hand in 1634. The story of his happy marriage is told in a series of paintings, drawings, and engravings that record all their tender, joyful, and sad moments together. More than any other artist in history, Rembrandt invites us to share in his personal life, which he chronicled until Saskia died in 1642, exhausted by numerous pregnancies. Vermeer, on the other hand, treated his family with great reserve, and no certain portraits of his relatives are known to exist.

Gerard Ter Borch

To this day, parts of Vermeer's life remain obscure, and the chronological sequence of his works is difficult to assess. Interestingly enough, however, Vermeer's name appears frequently in conjunction with that of other artists, which would indicate frequent contact with fellow painters. Art historians of the 17th century link him with Carel Fabritius, which may imply a scholarly partnership. Documentary evidence records a friendship with Leonard Bramer (who was a witness at his wedding) and, most importantly, with Gerard Ter Borch, a major and significant artist. Born in 1617 and therefore 15 years Vermeer's senior, Ter Borch was an educated man of wide-ranging culture. After completing his studies in Haarlem (with Frans Hals) and Amsterdam (with Rembrandt), Ter Borch spent almost ten years travelling around Europe and becoming immersed in the most up-to-date international trends of the time. On his return to Holland in 1644, he settled in Amsterdam, subsequently moving to Delft, and finally to Deventer. An elegant portrait painter, Ter Borch was also a sharp observer of domestic life, which he recorded in magnificent scenes of family interiors.

▼ Gerard Ter Borch, *Parental Admonition*, 1654–1655, Rijksmseum, Amsterdam. A typical expression of 17th-century Dutch social customs, as well as a magnificent painting, this work displays a bold use of color, with the girl's shiny, silvery gown standing out against the scarlet of the furnishings.

▲ Gerard Ter Borch, *Portrait of Helena van der Schalke*, Rijksmuseum, Amsterdam. Ter Borch was a master of sensitive and convincing portraiture.

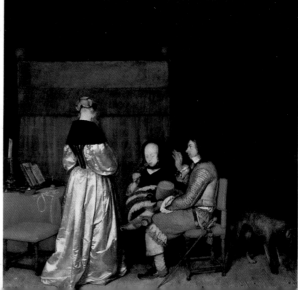

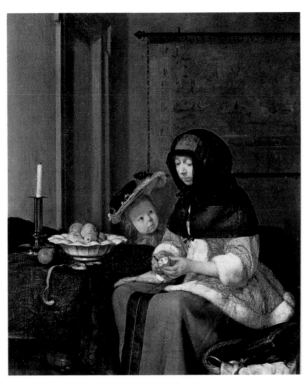

◀ Gerard Ter Borch, *Woman Peeling Apples*, 1651, Kunsthistorisches Museum, Vienna. Ter Borch does not quite match Vermeer's dazzling genius, his delicate treatment of light, and his psychological insight. However, a painting such as this shows us that Vermeer's delicate and charming pictures are not an isolated phenomenon in the history of art but in fact fit into the Dutch tradition of works that are in tune with the poetry of everyday life – the tranquil and touching beauty of gestures, looks, and feelings.

▶ Gerard Ter Borch, *A Woman Playing a Theorbo to Two Men*, National Gallery, London. In his more successful paintings, Ter Borch manages to capture and describe complex psychological situations. This work is also an example of his frequent use of a strong contrast between prevailingly muted shades and the luminosity of light-colored, rustling gowns.

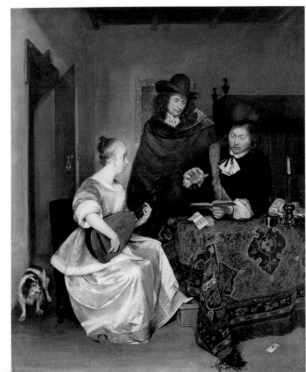

Catholic or Calvinist?

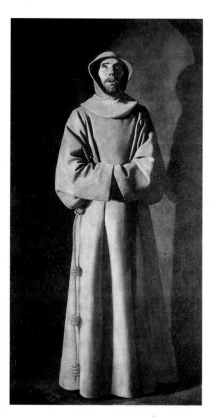

▼ Francisco Zurbarán, *Ecstasy of Saint Francis*, 1650–1660, Musée des Beaux-Arts, Lyons. In contrast to the Calvinists, Catholics continued to demand pictures of saints. In the 17th century, many paintings and sculptures in Catholic countries focused on saints, shown either carrying out brave and glorious deeds or striking soberly spiritual poses.

Much of the speculation surrounding Vermeer's early life and artistic development concerns his religion. Holland had adopted Calvinism as its official religion and as a persuasion that provided its people with a sense of unity and identity. In spite of this, it was one of the most open-minded and tolerant countries in Europe, with well-integrated Catholic and Jewish minorities, as well as other Protestant groups. It is very likely that Vermeer's family was originally Calvinist, whereas it appears that his wife Catharina Bolnes belonged to the Catholic minority. To appease his mother-in-law, Vermeer may also have embraced the Catholic faith, as is evidenced by his move to the Catholic quarter of Delft, in the area around the Oude Kerk, and most of all by his devotional painting *Saint Praxedes*, which celebrates the cult of the saints, abolished by Calvinism but re-established by the Counter-Reformation as a distinctive feature of Catholic devotion.

◀ This is a rare portrait of John Calvin, the famous preacher of the Reformation. The painting, housed in the Bibliothèque Publique et Universitaire in Geneva, was at one time erroneously attributed to Titian.

◀ Peter Paul Rubens, *Portrait of Matthaeus Yrselius*, Statens Museum for Kunst, Copenhagen. An abbot at the convent of St Michael at Antwerp, the prelate was one of the most influential Catholic figures in the Netherlands. Belgium, unlike the Calvinist United Provinces, had remained mostly Catholic.

▼ Vermeer, *Saint Praxedes*, 1655, Barbara Piasecka Johnson Foundation, Princeton. This elegant painting, inspired by a similar work by the Florentine artist Felice Ficherelli that may have passed through Vermeer's father's inn, is one of the more recent and interesting additions to Vermeer's catalogue of works.

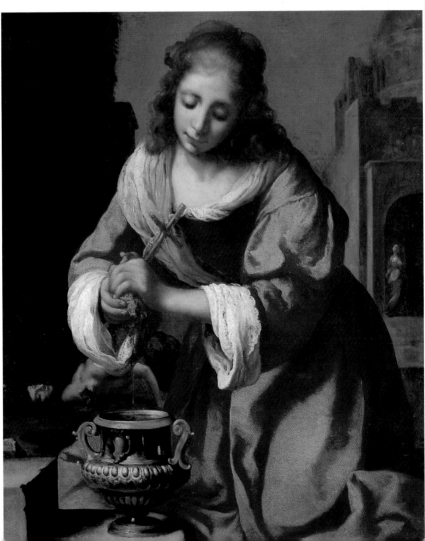

The Procuress

Painted in 1656 and housed in Dresden's Gemäldegalerie, this painting marks a turning-point in Vermeer's career. The large figures and the generous, almost square format (143 x 130 cm/ 56¼ x 51¼ in) link it to the early works, whereas the subject, which is neither mythological nor religious but more contemporary in character, heralds the later masterpieces, in which a poetic and sensitive interpretation of reality prevails.

◀ Paris Bordon, *The Venetian Lovers*, c.1540, Pinacoteca di Brera, Milan. The theme of procuring appears frequently in 16th-century Venetian painting and inspired masterpieces by Giorgione, Titian, and their circle. In terms of theme, format, and style, Vermeer's painting can thus be placed somewhere between the Italian influence and the Northern tradition.

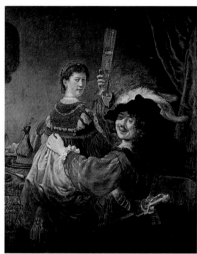

▶ Rembrandt, *The Parable of the Prodigal Son (Self-portrait with Saskia)*, c.1635, Gemäldegalerie, Dresden. Relaxed and uninhibited, Rembrandt portrays himself and his wife as the prodigal son and a prostitute. This is deliberately provocative, but also acts as a cheerful invitation to us to enjoy the good things in life, and to share our happiness with others. Rembrandt turns towards us, inviting us to join him in a toast.

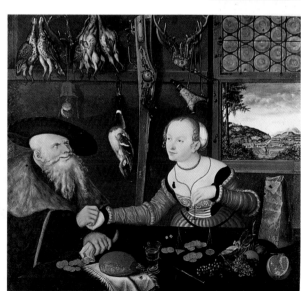

◀ Lucas Cranach the Elder, *The Prostitute*, 1532, Nationalmuseum. Northern paintings often deal with the subject of prostitution. This painting explores the theme in all its aspects, blending a moralistic tone with a sense of everyday realism. To bring it in line with 16th-century trends, Cranach's Renaissance scene includes a still life of game on the wall in the background.

The Guild
of St Luke

Membership of the painters' guild was mandatory in Holland in order for an artist to be able to practise his craft professionally. The country's social life was organized into a dense network of such guilds, which trained its members and set up solidarity funds to support widows, orphans, and colleagues experiencing financial difficulties. The guilds also acted as a barrier to excessive arts and crafts activities. These organizations always remembered their patron saint (and occasionally observed the saint's feast day) by taking his name. The patron saint of artists is Saint Luke who, according to legend, is said to have portrayed the Virgin in an icon. Vermeer was a prominent member of the Guild of St Luke in Delft; his father had been a member before him, in his capacity as art dealer. Vermeer joined the guild on December 29, 1653, as a "master painter", a job-title he used less than two weeks later in a legal document. Vermeer's name features several times in the guild's records, listing not only his annual subscription fee but also recording the social projects with which he was charged. He was twice, in 1662 and 1670, asked to hold the biennial post of senior member.

▲ Jan Lievens, *Portrait of Rembrandt*, c.1629, Rijksmuseum, Amsterdam. Lievens and Rembrandt opened a joint studio in Leiden, working in close conjunction with one another. The bond between the two young artists formed an interesting start to their individual careers.

▼ Michiel Sweerts, *A Painter's Studio*, c.1650, Rijksmuseum, Amsterdam. During their apprenticeship in the studio of established artists, aspiring painters would copy casts of classical sculptures.

▲ This 18th-century drawing (now housed in the National Gallery, Washington, DC) shows the guild of St Luke in Delft, headquarters of the painter's guild.

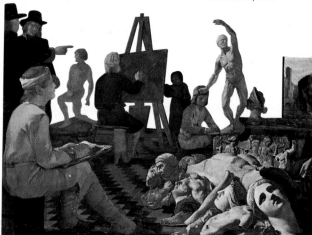

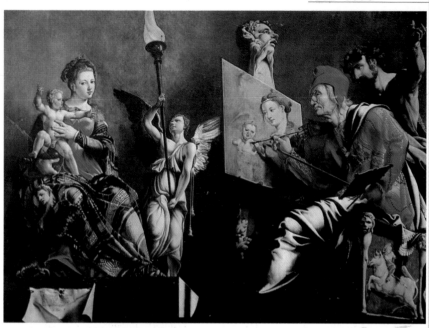

▲ Marten van Heemskerk, *St Luke Painting the Virgin*, 1552, Frans Hals Museum, Haarlem. Pictures connected with the cult of St Luke, often produced to decorate the meeting halls of the painters' guilds, provide realistic illustrations of the artist's craft from the Renaissance onwards.

▲ Gabriel Metsu, *Self-portrait with Easel*, c.1660, Sforza Castle, Milan. Comparisons are often drawn between the work of Metsu and Vermeer.

▶ Jan Josef Horemans, *A Painter's Studio*, Sforza Castle, Milan. Horemans' more populist style is in contrast with Metsu's ostentatious elegance.

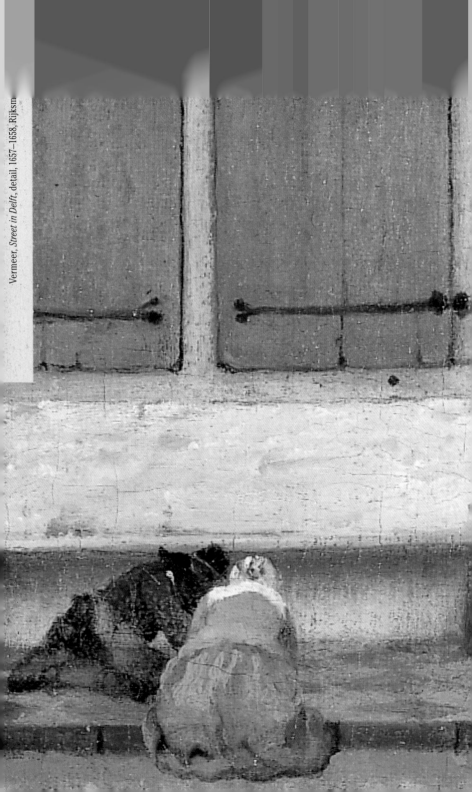

Important choices

Rembrandt

By the mid-17th century, Dutch art had developed its own varied and composite language and boasted a thriving antiquarian trade. Dutch painters, however, were hardly ever able to enjoy the same level of earnings or social standing as their counterparts in other countries. Almost all of them had to hold down a second job and for the most part tended to specialize in a particular subject in order to appeal more specifically to dealers and customers. Rembrandt also had to work within these restrictions and his achievement is all the more extraordinary when we take this into account. The artist, who was born in Leiden in 1606 and died in Amsterdam in 1669, was a painter able to excel in a variety of works that were widely divergent in terms of subject, format, and technique. Even his decision to sign his work with only his forename shows how he wanted to align himself with Italian Renaissance painters such as Titian. His life story and career are characterized by an intense urgency that is almost unparalleled in the history of art. His paintings display a wealth of artistic solutions, from the elegant early canvases to the thick, dramatic brushwork of his mature years.

▼ Rembrandt, *The Presentation in the Temple*, 1630, Mauritshuis, The Hague. This is a typical example of the meticulous, almost miniature-like quality of Rembrandt's youthful works, executed while he was still in his native Leiden.

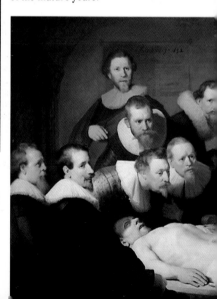

▶ Rembrandt, *The Anatomy Lesson of Doctor Tulp*, 1632, Mauritshuis, The Hague. A dramatically evocative painting and a totally original treatment of the portrait genre, this marked Rembrandt's entry into Amsterdam's artistic life.

◄ Rembrandt, *Peter's Denial*, c.1660, Rijksmuseum, Amsterdam. In his later works, Rembrandt used chiaroscuro in a dramatic, highly atmospheric way.

▼ Rembrandt, *Saskia in a Hat*, c.1635, Staatliche Museen, Kassel.

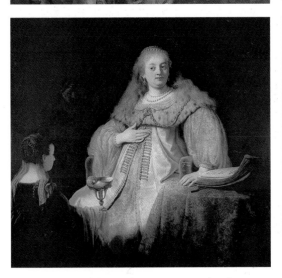

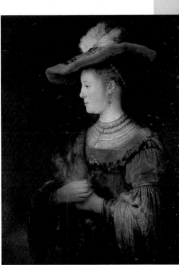

▲ Rembrandt, *Artemisia or Sophonisba*, 1634, Museo del Prado, Madrid. Although Rembrandt painted a variety of different subjects, he frequently expressed his predilection for themes drawn from mythology or ancient history, which he interpreted with grandiose and exuberant theatricality, in the manner of the Italian Renaissance masters.

The gentle muses of a sensual artist

Rembrandt's paintings feature a number of women, almost invariably real figures who were close to him. As a boy, he used his mother and sister as models, then, during the all-too-brief happy years when he was married to Saskia, his wife became the dominant figure in his works. Rembrandt painted her in a number of different guises, from a subdued domestic context to more exotic and theatrical settings.

Symbols, allegories, and emblems

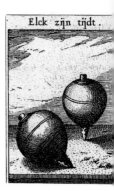

Elck zijn tijdt

▲ Roemer Visscher, *To Each his Time*, from the *Sinnepoppen*, 1614. Spinning-tops are a symbol for the passing of time: they spin, then gradually and inevitably come to a standstill. They feature as a reminder of the brevity of life in the painting on the right, which commemorates the slaying of William the Silent.

A country's identity is formed by its experience of great historical events and powerful feelings that bring its people together, as well as a range of common habits, vocabulary, traditions, tastes, and costume that enable the people to feel close to one another. The United Provinces, once it had thrown off the Spanish yoke, explored every avenue in order to justify and consolidate its national identity and to make it distinctive and easily identifiable. Besides the fundamental elements – such as the Calvinist religion, a sound economic system and social structure, and a vigorous drive towards literacy that would enable the Dutch language to establish itself – all manner of everyday customs and products served to promote a sense of national solidarity. These included the widespread availability of collections of proverbs, mottos, and sayings, which acted as a compendium of the common mentality of the people. Schoolbooks also included popular nursery rhymes, riddles, and sayings, shaping a language based on symbols and allusions. In the same vein, many details in Vermeer's paintings refer to the visual world of symbols and allegory.

▲ Adriaen van den Venne, *How Well We Look!* c.1640, Statens Museum for Kunst, Copenhagen. This is a witty parody of Dutch 17th-century portraits.

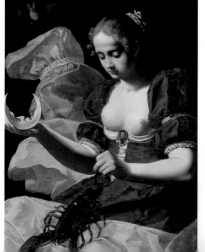

▼ Scholars have still not been able to attribute this charming painting. The work, by a 17th-century Dutch artist, shows the allegory of inconstance and is housed in the Statens Museum for Kunst in Copenhagen. The colors, the clothing, and the objects held by the figure (the crescent moon and the lobster) are taken from *Iconologia* by Cesare Ripa, a widely-read collection of allegories and symbols published in several instalments and heavily illustrated. The style of the painting recalls similar Italian examples.

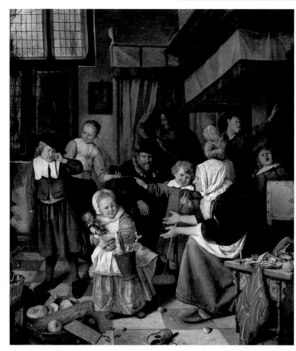

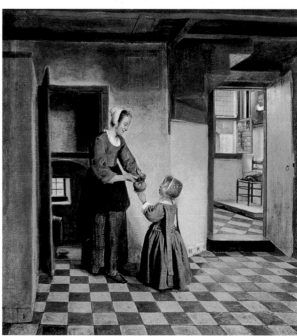

▲ Jan Steen, *The Feast of St Nicholas*, Rijksmuseum, Amsterdam. Whether rascals or little angels, children are a constant feature in 17th-century Dutch painting. Steen participates in the opening of these Christmas gifts as an amused observer.

◀ Pieter de Hooch, *The Larder*, 1658, Rijksmuseum, Amsterdam. The mother dutifully teaches her daughter how to become a good housewife in this serene family scene, set in a spotless interior. It is a perfect example of the Dutch way of life in the 17th century.

41

Women in Dutch society

When European travellers returned home from 17th-century Holland, they always commented on the particular role played by women. Good nourishment and a natural tendency to be stout made Dutch women unusually robust and energetic. Their zealous housekeeping was proverbial and they displayed an almost obsessive attention to the slightest detail, not only in the house itself, but also in the neighboring stretch of road or riverbank, the upkeep of which was the legal responsibility of the families who overlooked it. Thanks to this, Dutch cities were much cleaner than other European centers. According to Calvinist doctrine, women were the guardians of the family, responsible for the children's education, and the protectors of morality and order. The state, for its part, saw to the upkeep of widows and orphans, particularly those who were the surviving relatives of victims of a tragedy at sea. Inevitably, this clean-living exterior had its dark side, too: behind its upright façade, Holland concealed a crisis in marital relations, which was expressed in the form of adultery and prostitution, widespread divorce, and the division of possessions.

▼ Rembrandt, *A Girl Leaning on a Stone Pedestal*, 1645, Dulwich Picture Gallery, London. Rembrandt often pauses in his description of a particular episode in order to capture the psychology behind it, in this case the thoughts of a girl on the verge of adolescence.

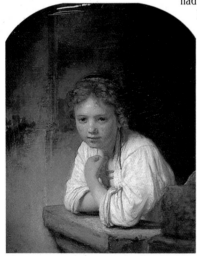

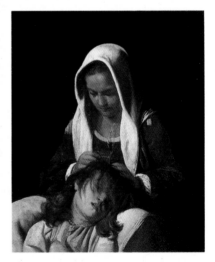

▶ Michiel Sweerts, *The Toilet*, Musée des Beaux-Arts, Strasbourg. Mothers patiently grooming their children is a recurring theme in Dutch painting. It was a mother's duty to get rid of any impurity in the family.

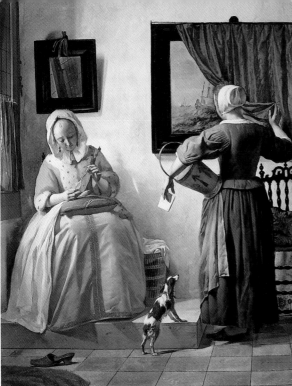

◄ Gabriel Metsu, *Lady Reading a Letter*, c.1663, National Gallery of Ireland, Dublin. In paintings showing a conversation between women from different social strata, such as a lady and her maid, female confidences were seen to overcome class barriers.

▲ Rembrandt, *The Artist's Mother as the Biblical Prophetess Hannah*, 1631, Rijksmuseum, Amsterdam. This painting highlights the moral and intellectual values of old people.

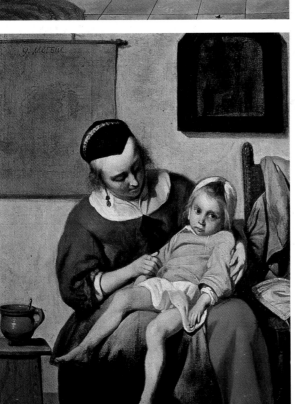

◄ Gabriel Metsu, *The Sick Child*, c.1660 Rijksmuseum, Amsterdam. Mothers in 17th-century Holland were renowned throughout Europe for the loving care they gave their children.

43

A painter of the female universe

More than any other artist in 17th-century Holland and, arguably, in the entire history of art, Vermeer reveals an extraordinary ability to enter into the female mind, in all its feelings and secrets. A substantial part of his production was devoted to domestic interiors, which often included one or two female figures. Silence dominates all these paintings, broken only by the scratching of a pen over a sheet of paper, a tune played on a harpsichord, the strum of a guitar, milk pouring from a jug, the sound of a reel on a lace pillow, or, more frequently, an ill-concealed sigh, a smile, or a fleeting expression. With great delicacy, almost on tip-toe, Vermeer introduces us into the myriad subtleties of the female universe including modesty, reined-in joy, quiet reflection and moments of animation, worry, and passion. He was, of course, surrounded by women – mother, sisters, daughters – but it has never been possible to identify any of them with any certainty in his paintings. All Vermeer's women are nameless and have no background story. They are suspended in time as perpetual archetypes but the artist nevertheless paints them with an affection that often borders on love.

◀ Vermeer, *Lady with her Maid,* c.1670, National Gallery of Ireland, Dublin. The respective countenances of the lady and her maid point to the difference in their social status.

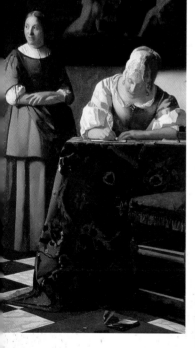

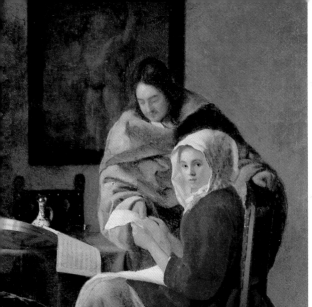

◄ Vermeer, *Girl Interrupted at her Music*, 1660–1661, Frick Collection, New York. This may not be Vermeer's greatest masterpiece but it still reveals the depth of his psychological insight. The man may be an aristocratic suitor, and the background painting of Cupid would seem to affirm this. While he focuses on the score, the woman appears to be much more interested in the world around her.

▶ Vermeer, *Sleeping Girl*, 1657, Metropolitan Museum of Art, New York. This is one of those rare and precious works that lie somewhere between Vermeer's youthful period and the beginning of his "genre" phase. It is a still life in every sense, from the magnificent Oriental carpet in the foreground to the stillness of the sleeping girl. The carafe of wine hints at her drunkenness.

◄ Vermeer, A *Lady Writing*, detail, c.1665, National Gallery of Art, Washington, DC. The subject is dressed in a distinctive yellow, the color Vermeer frequently favors for women's clothing.

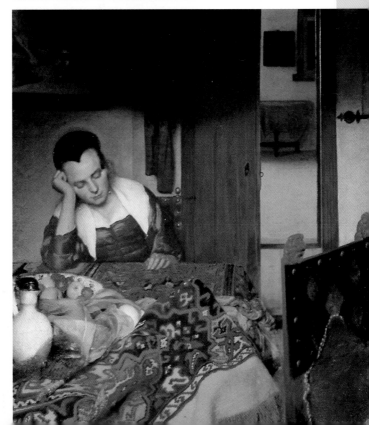

1656–1665

Woman in Blue Reading a Letter

Housed in Amsterdam's Rijksmuseum, this painting dates from 1663–1664. Some scholars are intrigued to know more about the woman, whether she is pregnant, as her appearance suggests, what kind of news the letter contains, and whether she is a relative of the artist. Others have drawn attention to the highly balanced compositional harmony of the scene, and the perfect geometric connection between all the different elements in the painting.

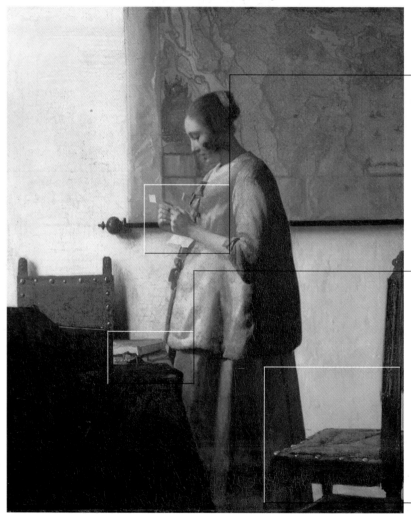

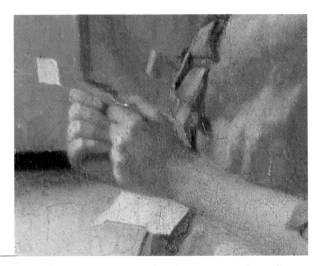

◀ Despite detailed comparisons with the fashion of the day, it has still not been possible to ascertain whether the decidedly matronly appearance of the young woman is due to pregnancy or simply to the cut of her clothes. The light falls on the letter, focusing the viewer's attention on the contrast between the ray of light and the pale blue gown.

▶ The table, with the discarded pearls, shows Vermeer's attention to minute detail, with particular care taken in the depiction of light. This preciseness may account for the artist's slowness in executing his paintings – and explain why his works are so few.

◀ The empty chair, the map, and the letter may be a reference to someone who is absent, perhaps the woman's husband. Vermeer never enters fully into his sitters' lives; he confines himself to hinting at their situation, without ever invading their reserve or intruding on their personal secrets.

The development of portraiture

▼ Frans Hals, *Fisherman Playing the Violin*, c.1630, Thyssen-Bornemisza Collection, Madrid. In addition to his proper portraits, Hals also painted studies based on ordinary people, executed with vivid brushstrokes and vibrant colors.

▶ Johannes Verspronck, *Portrait of a Girl*, c.1641, Rijksmuseum, Amsterdam. This is a typical example of the precious, detailed, analytical execution favored by Dutch patrons.

Vermeer was part of the collective celebration of the portrait in Dutch 17th-century painting. Aiming their work at a market made up mostly of members of the bourgeoisie, Dutch artists were frequently called on to produce a likeness of their patrons. Portraits commissioned in this way were generally more lucrative than paintings sold on the open market through gallery owners and dealers. As with other aspects of Vermeer's life and work, we have no information as to specific commissions: portraits such as the world-famous *Girl with a Pearl Earring* enter more comfortably into the typically Dutch category of *tronijes*, or character studies. This explains why the execution is neither carefully drawn nor sharply defined, but colored rather by a vague, seductive evocation. Rembrandt and Frans Hals, undoubtedly the greatest Dutch portraitists of all, also painted ordinary people on many occasions, employing a different technique from the one they reserved for the portraits they painted to commission.

◀ Rembrandt, *The Mennonite Minister Cornelis Anslo*, 1641, Staatliche Museen, Berlin. Portraits make up an important part of Rembrandt's output.

▼ Vermeer, *Girl with a Pearl Earring*, c.1665, Mauritshuis, The Hague. One of the key paintings in Vermeer's oeuvre, this portrait resists all attempts at the precise identification of the sitter. Its charm, perhaps, lies in the fact that it is an evocative expression of timeless female beauty.

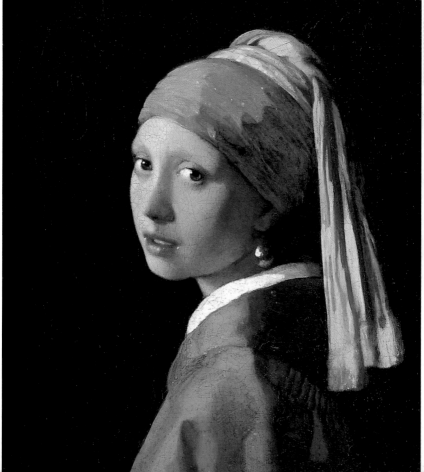

49

The Golden Age draws to a close

▼ Rembrandt, *Self-portrait*, 1652, Kunsthistorisches Museum, Vienna. Proud of his work as a painter, Rembrandt confronted with consummate dignity his physical decline, the disintegration of his family, financial ruin, and changing tastes in art.

▶ Willem van de Velde, *The Arrival of the Admiral's Ship Gouden Leeuw (The Golden Lion) at the Source of the River Y at Amsterdam*, 1686, Historisch Museum, Amsterdam.

By the mid-17th century, the first signs of the Republic's long decline had begun to appear. Constantly threatened by repeated wars with England, then attacked by the rampant expansionist policy of the Sun King, Holland was repeatedly forced to clash with the great European powers. Small but feisty, Holland always succeeded in fending off each attack, strengthened by a solid core of national solidarity and precise hydrography. After each war, however, the country was left a little worse off, with a palpable awareness that its period of economic growth and international standing was coming to an end. The new generation was disinclined to engage in bold adventures: unlike their fathers and grandfathers, young merchants and businessmen had not experienced the difficulties and challenges of the early decades of the century, during the heady time in which territorial independence was defended and the supremacy of the ocean routes secured. The House of Orange, too, succumbed to the new mood, moving towards becoming a real "royal family" rather than the descendents of the republic's lieutenants. Tastes in art also changed after 1660, with the favoring of a more "international" culture characterized by a pleasant, but fundamentally anonymous classicism.

▲ Gerard de Lairesse, *The Five Senses*, 1668, Private Collection/Art Gallery and Museum, Glasgow. A pupil of Rembrandt's, de Lairesse became the main interpreter of the classical trend that became fashionable after 1660.

▶ Jan Steen, *The Farm Courtyard*, 1660, Mauritshuis, The Hague. Jan Steen's work lost some of the irony and social satire of his early years, becoming more narrative in tone and rich in lovingly painted details.

51

The Milkmaid

Dating from about 1660, this famous painting is now housed in Amsterdam's Rijksmuseum. Although it may be based on Italian prototypes, it is one of Vermeer's most typical works, the action gently illuminated by a soft ray of light.

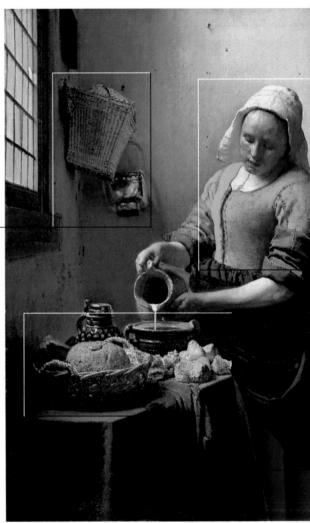

▲ Nothing is gratuitously included: even the objects hanging in the half-light, tools of everyday life, point to a social context and to the domestic background of the household. They also demonstrate the almost chameleonlike quality of Vermeer's brushwork, which gracefully evokes different textures and surfaces.

▶ Jan Rinke, *Uncle Sam and the Milkmaid*, cartoon by Het Vaterland, 1907. Vermeer's milkmaid has become the very symbol of Holland, a popular allegory that also featured in satirical drawings such as this.

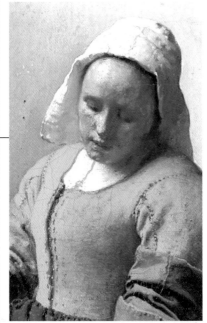

◀ The interpretation of the milkmaid as an allegorical figure is by no means a recent one. We can speculate that Vermeer intended her to be a symbolic representation of the entirely Dutch virtue of temperance, so intent is she on not wasting a single drop of the milk.

▼ Here, as in many other of Vermeer's paintings, the charm of the figure can almost make us neglect the care with which the artist has created the rest of the scene. The still life on the table is rendered with skilful realism.

Vermeer and the civic militia

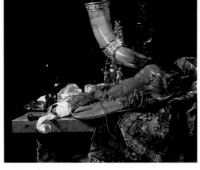

▲ Willem Kalf, *Still Life with the Drinking Horn of the Saint Sebastian Archers' Guild,* 1653, National Gallery, London. The symbolic objects belonging to the guilds were preserved with great care and many have survived to this day.

Although little is known of Vermeer's life, one certain and documented event is his membership of the Delft civic militia, to which he was admitted in 1664 at the age of 32. He was not a conscript. The date is interesting, because it can be viewed in connection with the threat of a further war with England, which broke out in 1665. The coincidence in the dates leads us to view Vermeer as a bellicose figure. However, membership of the civic militia did not necessarily mean taking up arms; in many cases, groups were responsible for maintaining order in the towns, with somewhat limited duties, and being a good citizen meant having to take on this onerous task of responsibility towards the community. During peacetime, and given the substantial social affluence brought about by Holland's thriving economy, members of the civic militia carried out little more than the occasional night watch and organized parades or the reenactment of the United Provinces' most heroic events. Their banquets were known to turn into spectacular feasts and drinking sessions.

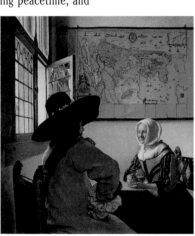

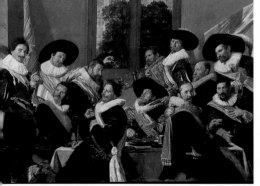

◄ Frans Hals, *Officers of the Civic Guard of St Hadrian at Haarlem,* 1627, Frans Hals Museum, Haarlem. Many of Frans Hals' paintings show gatherings of civic militia companies or guilds.

▲ Vermeer, *Soldier and Laughing Girl,* 1655–1660, Frick Collection, New York. Vermeer's paintings frequently feature easy-going soldiers, often engaged in seduction or dalliance.

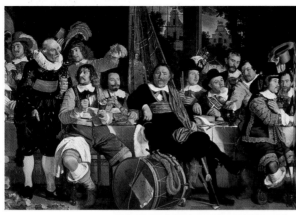

◀ Bartholomaeus van der Helst, *Banquet of the Civic Guard*, 1648, Rijksmuseum, Amsterdam. Members of civic militia companies were glad of an excuse to gather together their "companions at arms" and make merry. The Peace of Westphalia is being celebrated here, with abundant libations.

▶ Rembrandt, *The Night Watch*, 1642, Rijksmuseum, Amsterdam. This painting shows the civic militia company of Captain Frans Banning Cocq. It was executed for the seat of the Civic Guard in Amsterdam, and paid for by several of the sitters, the amount contributed determined by their seniority within the group.

▼ Vermeer, *The Glass of Wine*, c.1662, detail, Staatliche Museen, Berlin. In contrast to the raucous group portraits of the Civic Guard companies, Vermeer's paintings always express an atmosphere of tranquillity and intimacy.

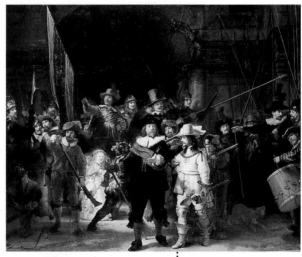

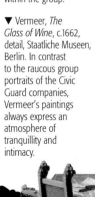

The Night Watch

The title of the most famous painting in Dutch art is actually a misnomer. This was no "night watch" intended to deter crime, but a peaceful and ceremonial parade. The scene is not set at night but in the daytime, and the dark background is owing only to the deterioration of the colors on the canvas over time. Rembrandt's painting remains one of the best examples of group portraiture in the entire history of art.

The outdoor world

Almost all of Vermeer's paintings are set in bourgeois interiors. Only rarely does the artist turn his attention to what is happening outside the home in the city streets: Street in Delft and View of Delft, the latter regarded as the artist's supreme masterpiece, are the great examples. Vermeer was interested in outdoor scenes and landscapes not so much for their precise documentation of a given view or monument, nor as a means to capture the prevailing weather at a particular moment in time; instead, he viewed the outdoors as the context within which people's lives unfolded. Always driven by his interest in matters of emotion and the foibles of human nature, he inserts small human figures into his landscapes: at first glance, they are peripheral details, but we quickly realize that the view depicted is actually measured in terms of these people. Dutch landscape painting flourished in the 17th century, and examples abound. Among the foremost painters of the day were Pieter Saeredam, who devoted himself almost entirely to whitewashed church interiors; Jacob van Ruysdael, who concentrated on the open countryside; Jan van Goyen, who favored seascapes; and Jan van der Heyden, who specialized in townscapes.

▼ Pieter Saenredam, *Interior of the Church of St Odolphus at Assendelft,* 1649, Rijksmuseum, Amsterdam. Saenredam developed his own geometric system to reproduce the exact proportions of buildings with accuracy.

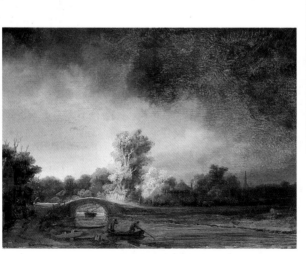

◀ Rembrandt, *Landscape with a Stone Bridge,* c.1635, Rijksmuseum., Amsterdam. Rembrandt produced views of the Dutch countryside only rarely in his career.

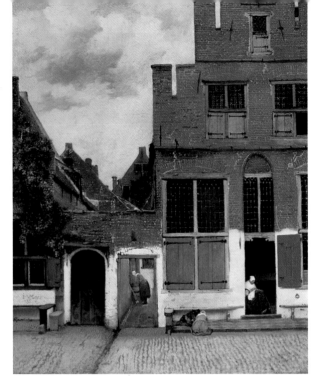

◀ Vermeer, *Street in Delft*, 1657–1658, Rijksmuseum, Amsterdam. The house shown, late Gothic in style, may have been Vermeer's own home. He is thought to have lived there until 1661, when the building was knocked down to make way for the Guild of St Luke, the artist's guild in Delft.

▼ Jan van der Heyden, *View of the Westerkerk, Amsterdam*, 1660, National Gallery, London. Like Saenredam, van der Heyden used scientific instruments in order to reproduce architecture and urban spaces with the utmost precision. Rembrandt was buried in this church in 1669.

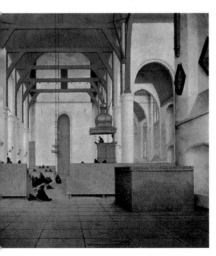

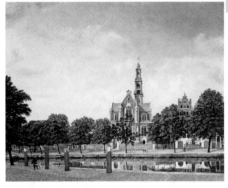

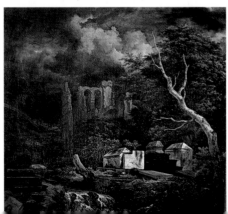

▶ Jacob van Ruysdael, *Jewish Cemetery*, Gemäldegalerie, Dresden. The enduring power and charm of this painting makes it one of the artist's most accomplished masterpieces. Van Ruysdael specialized in evocative landscapes and his taste in weather conditions anticipated the Romantic view of nature.

View of Delft

This work, which dates from 1660–1661, now hangs in the Mauritshuis in The Hague. A world-famous painting, it is unique in Vermeer's work. It is a free and poetic interpretation of the city rather than a detailed, realistic landscape.

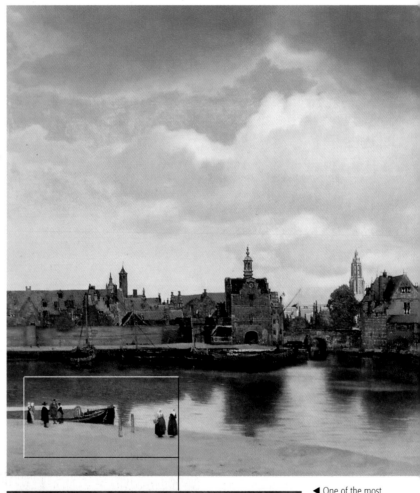

◄ One of the most innovative features of the painting lies in the figures. In paintings by Vermeer's contemporaries, figures are inserted into the

▶ Egbert van der Poel, *A View of Delft After the Explosion of 1654*, National Gallery, London. Here, the city of Delft is shown torn apart by the tragic explosion.

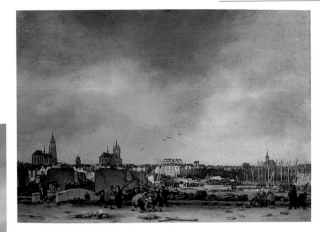

◀ The most recognizable monument in the painting, probably based on drawings, is the Rotterdam gate, with its two conical turrets. Once part of a circle of 15th-century fortifications, its structure is faithfully reproduced by Vermeer – a fact confirmed by the study of comparable works by other artists. In terms of the accuracy of its placement, however, it has been positioned too far to the right.

▶ The historical appearance of the city, surrounded by its walls and canals, was analysed in a "Large Map of Delft", printed in Amsterdam between 1675 and 1678. Dominating the view shown here are the Gothic steeples of the Oude Kerk (on the left) and the Nieuwe Kerk.

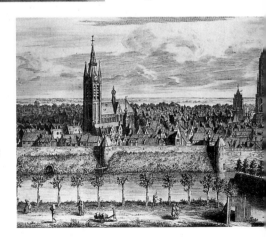

landscape as adjuncts to it, an expression of the commercial or social activity of the city, whereas for Vermeer they are a simple, human presence.

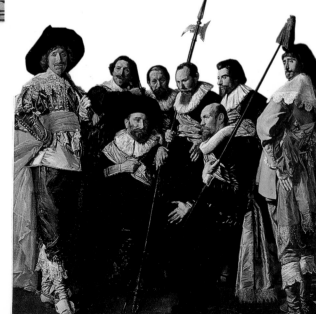

Developments in politics and art

▼ Pieter de Hooch, *Visitors in the Council Chamber of the New Town Hall at Amsterdam*, Thyssen-Bornemisza Collection, Madrid. The new town hall, the work of Jacob van Campen, is a magnificent example of classicism.

▶ Frans Hals and Pieter Codde, *The Company of Captain Reynier Reael*, 1636, Rijksmuseum, Amsterdam.

By the mid-17th century, Holland had reached the apogee of its glory. Recognized as independent by the Peace of Westphalia (1648), the country enjoyed the fruits of a shrewd commercial and colonial policy. Its wealth, however, which was lavishly celebrated, generated a continued rivalry with neighboring countries. The Dutch fleet was obliged to clash repeatedly with the English navy, which three times (in 1652, 1665, and 1672, the year of Vermeer's death) waged war with Holland. The great European powers constantly attacked the small northern nation: they never succeeded in conquering it, but they were able to halt its expansion. An example of this was the fate of the North American colony of Nieuwe Amsterdam, founded in 1625, which was ceded to the English 40 years later in exchange for Surinam and renamed New York. In the second half of the 17th century, Holland, whose internal affairs were characterized by strong social stability, found herself at the center of a delicate international political situation. The life of Vermeer and his wife was conditioned by a frequent state of alert, and the artist's joining of the Delft civic militia in 1664 provides documentary, bureaucratic evidence of this.

▶ Abraham van Beyeren, *Still Life*, Rijksmuseum, Amsterdam. After the mid-century, Dutch collectors preferred to purchase lavish and exuberant still lifes, which were very different in style to the sober and "moralizing" still lifes of previous decades. A Baroque taste came to dominate the genre, and luxurious still lifes such as this one were much in demand.

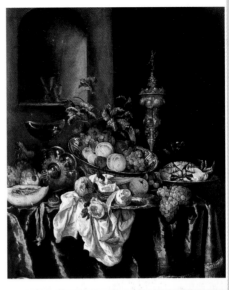

▲ Rembrandt, *Jacob Blessing the Sons of Joseph*, 1656, Staatliche Museen, Kassel. Rembrandt was the most famous victim of the new developments in Dutch artistic taste at this time. His intense, vibrant canvases now came to be regarded as roughly sketched and unfinished.

▲ Rembrandt, *The Conspiracy of Julius Civilis*, 1661, Statens Konstmuseer, Stockholm. Despite his failing popularity, Rembrandt still received some prestigious public commissions. This painting is a surviving fragment of a much larger work, painted for the New Town Hall.

The painting within a painting

▶ Vermeer, *The Concert*, 1665–1666, Isabella Stewart Gardner Museum, Boston. Hanging on the wall, next to a landscape reminiscent of van Ruysdael, is *The Procuress*, painted by Dirck van Baburen in 1622. The inclusion of this painting may not necessarily point to a moralizing intention on Vermeer's part but may merely reflect the persisting Italianate taste of Dutch collectors.

An appealing feature of Vermeer's works is the reproduction in his interiors of paintings by other artists. This was nothing new, nor was it a characteristic exclusive to him. Nevertheless, Vermeer pays more attention to these details than other artists working at this time. They are not mere ornaments or artefacts common to the interior decoration of the day, but highly significant elements. In some cases, the painting introduced into the composition is a crucial device enabling us to understand symbolic meanings or allegorical references. It must not be forgotten that Vermeer's father acted as an art dealer as well as an inn-keeper and that Vermeer himself also engaged in this activity. From childhood, Vermeer had been used to living among paintings and acquired a taste for collecting them; he was able to assess their value, both artistically and financially. Although not in the same league as Rembrandt, who during his most successful years put together an enormous and varied art collection, Vermeer can still be regarded as an artist and collector.

▼ Van Baburen's painting, clearly one of Vermeer's favorites, reappears in the background of *A Young Woman Seated at a Virginal*, c.1670. One of the few paintings within a painting to be identified with any certainty, this canvas was part of Vermeer's own collection.

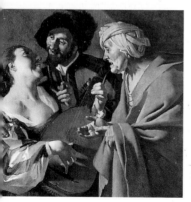

▲ Dirck van Baburen, *The Procuress*, 1622, Museum of Fine Arts, Boston.

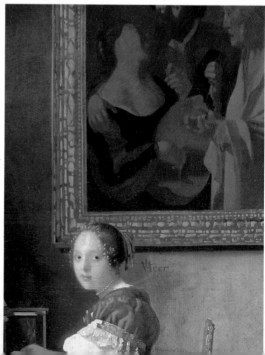

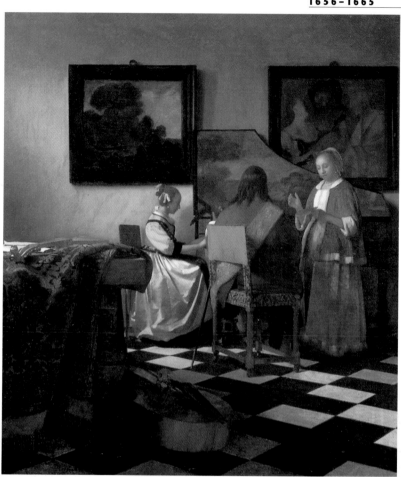

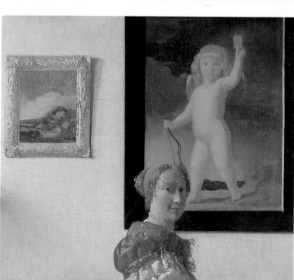

◀ Vermeer, *A Young Woman Standing at a Virginal,* detail, c.1670, National Gallery, London. This painting reflects the taste of bourgeois collectors. Next to the small landscape on the left hangs a pleasing early 17th-century painting, with the emblematic figure of Cupid holding up a playing card; the message is that one should love one person only.

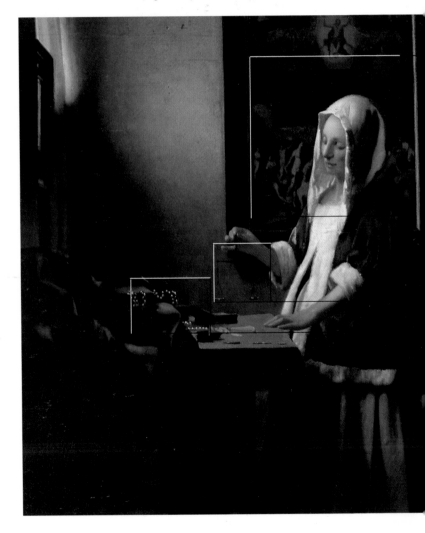

MASTERPIECE

Woman Holding a Balance

Dating from about 1664, this painting is housed in the National Gallery of Art, Washington, DC. It is one of Vermeer's less luminous interiors, with only a thin ray of sunlight shining through the window and lighting up the woman's white headdress and the fur trimmings of her gown. The scene includes an unexpected warning: the painting within a painting in the background shows the Last Judgment, when possessions such as gold and pearls will have no meaning.

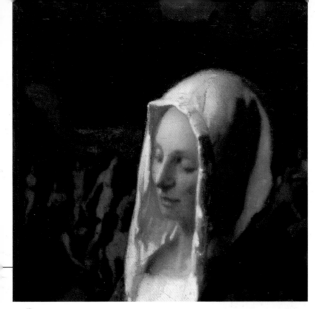

◀ The woman's pensive expression and her raising of the scales in front of a painting showing the Last Judgment has been viewed as a hidden Catholic allegory. The woman could symbolize the Virgin Mary interceding for man's salvation. This intercession begins with her role as mother of the Savior, which may explain why she appears to be pregnant.

▶ The scales are carefully drawn: examination under a microscope and chemical analysis of the color have proved that they contain neither gold nor pearls: the woman is simply holding them, perfectly balanced, with an elegant gesture and with rapt inner reflection. This is a powerfully virtuous image, which recalls traditional images of Justice (always shown holding the scales) as well as sober Temperance, who knows how to gauge the correct "weight" in all circumstances. Note how the woman is placed in front of the image of the Last Judgment in such a way as to cover the figure of St Michael, who holds the scales in his hand in order to separate the chosen ones from the reprobate.

◀ The jewels, set out on a blue cloth and glistening in the light, can be viewed as a temptation, a pleasure, thus fitting into the mystical context of the Last Judgment. The pearls, however, positioned on the same axis as the woman's stomach, hint at the purity of the Virgin Mary.

Vermeer's ascendancy

BACKGROUND

Artistic activity in Delft

▼ Frans van Mieris, *The Music Lesson*, Staatliches Museum, Schwerin. Van Mieris may, overall, be the artist who is closest to Vermeer in terms of feeling and style. His small masterpieces are exemplary in the intricacy of their execution and treatment of light. They do, however, lack the emotional insight that emerges so often in Vermeer's paintings.

From 1660, at a time when Delft enjoyed great success with its famous ceramics, the city embarked on what would be the most dazzling period in its painting history. Art writers of the previous century had mourned the sudden death of Carel Fabritius in the gunpowder magazine explosion of 1654, but now the situation was completely different. Besides Vermeer and Ter Borch, many of Holland's other great masters converged on Delft, including Jan Steen and Pieter de Hooch. Although no documents have survived to provide us with precise information as to the relationship between these artists and Vermeer, the stylistic and thematic affinities they share are evident enough to suggest frequent and cordial contact. This paved the way for the development of genre painting and of the stylistic and psychological treatment of subjects drawn from everyday life. At this time, Delft became a major center for the art market and was much visited by collectors. For a few years (before repeated wars with France spread a sense of despair throughout Holland), Delft could be considered a small, but important European art capital.

▶ Tavern scenes were much in demand on the Dutch and international art market and were wittily painted by many artists, including Jan Steen, who was a brewer as well as a painter. Significantly, Vermeer, despite running the family inn, includes no subject like this in his mature production.

▼ Jan Steen, *The Delft Burgher and his Daughter*, c.1665, Private Collection. A summary of Dutch 17th-century culture, this work reproduces a specific part of Delft, with the Nieuwe Kerk in the background. A wealthy burgher listens to the pleas of a poor woman: the contrast in their social station is emphasized by the different appearance of the two children.

◀ Vermeer circle, *Girl with a Flute*, 1668–1670, National Gallery of Art, Washington, DC. This painting stands alone as the only work that can be attributed to a collaborator or follower of Vermeer rather than to the master himself. The painting shares many affinities with *Girl with a Red Hat* (pp. 66–67 and 71). Some details are identical, such as the armrest in the shape of a lion. The overall effect is weaker in this work, however, and the young woman's expression lacks the inner depth of the women painted by Vermeer. In this sense, this work constitutes the only clue we have as to a Vermeer "school", breaking, albeit only momentarily, the serene isolation of his style.

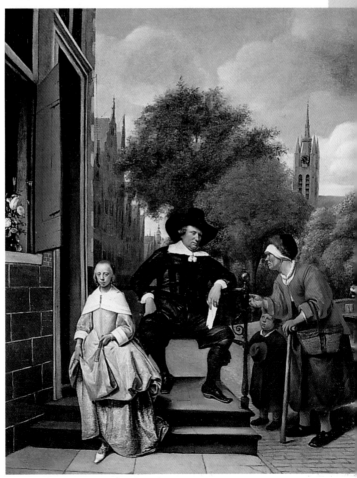

69

Family and art

Vermeer's whole life was spent in Delft, without any undue troubles or remarkable events. Documents relating to the artist and his family record a constant traffic between the baptismal fount and the cemetery. Vermeer and Catharina had an exceptional number of children, no fewer than 15, of which four died while still very young. Of the 11 orphans the artist left on his premature death, only one had come of age. Vermeer's family circle also included his sister Geertruijt, his mother Digna, and his mother-in-law Maria Thyns. Some of the women who appear in his paintings have been identified with his wife, his sister, and one of his daughters. This is the case with *Girl with a Red Hat*, whose identity has been the subject of much speculation. Nothing is known for certain, however: we have no known portrait of any of the artist's relatives, and to have any idea of his own likeness we can do no more than surmise that he included some self-portraits in a few of his works. Unlike other artists, such as Rembrandt, it appears that Vermeer preferred to keep his private life separate from his artistic activity.

▼ Rembrandt, *Family Group,* c.1667, Herzog Anton Ulrich Museum, Brunswick. This is a powerful evocation of family love and deep feeling, conveyed by means of deep, rich colors threaded through with golden lights.

▲ Frans van Mieris, *Portrait of his Wife, Cunera van der Cock,* 1657–1658, National Gallery, London.

◄ Vermeer, *Girl with a Red Hat*, c.1665, National Gallery of Art, Washington, DC. This small painting, touching in its immediacy, is the only one Vermeer executed on panel rather than on canvas. Although Vermeer cannot accurately be categorized as a portrait artist, many of his works include splendid examples of portraiture. Here, reflection from the wide-brimmed red hat, spreading out in a wispy but entirely tangible way, is cleverly achieved. The detail on the left, an armrest carved in the shape of a lion that almost dissolves in the light, is an example of his "Impressionist"-style brushstrokes.

▼ Rembrandt, *Two Women with a Child*, watercolor drawing, Kupferstichkabinett, Berlin.

Rembrandt: a sad end

Rembrandt's life, documented in many canvases and drawings, makes up a dramatically eventful page in the history of art. At a time when Vermeer was comfortably settled and surrounded by a bevy of children, Rembrandt's private life was reaching a tragic climax. In 1668, his son Titus died, the only surviving child of his marriage to his cherished wife Saskia, who had herself died as a result of his difficult birth. During the last year of his life (he was buried on October 8, 1669), Rembrandt was left alone.

Jan Steen and moral satire

▶ Jan Steen, *The Letter*, c.1663, Royal Collection. The subject refers to situations and feelings that were also typical in Vermeer's repertoire: the hidden message in a letter, an air of slight concern, curiosity, and female complicity.

Born in 1626 in Leiden (the birthplace of Rembrandt), Steen is one of the greatest Dutch artists of the 17th century. Unlike many of his fellow-artists, he chose not to reside in a single place, but moved from one center to another, thus placing himself above individual local schools of painting. Many of his paintings are in direct contrast to Vermeer's silent interior scenes, characterized as they are by an atmosphere of jocularity or amused irony. Steen's training took place in Utrecht and Haarlem, where he acquired a reasonable knowledge of Italian art and was able to admire Frans Hals' sophisticated, swift brushstrokes. In 1648, he married the daughter of the landscape artist Jan van Goyen and, after a period spent in The Hague, he moved to Delft. There, he alternated his activity as a painter with the more lucrative job of brewer. Later, after further travel, he returned to his native Leiden. He often painted the same subjects throughout his career, always discovering new angles and different interpretations, including realistic, ironic, and moralistic.

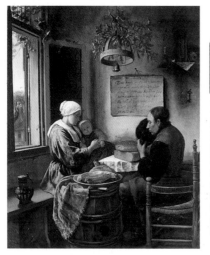

◀ Jan Steen, *Grace Before Meat*, 1660, Morrison Collection, Sudeley Castle. This is one of Steen's most concentrated paintings, conveying the sincere devoutness of humble folk with a sense of involvement and admiration.

▲ Jan Steen, *Self-portrait as a Lute-player*, Thyssen-Bornemisza Collection, Madrid. Striking up a light-hearted pose and a jovial expression, the painter gladly takes on the role of entertainer and ballad-singer.

▼ Jan Steen, *Tavern Scene*, Thyssen-Bornemisza Collection, Madrid. The subject is a lewd one: an insinuating weakling introduces a seemingly pregnant girl to the elegant customer who, with a distracted air, busies himself with tobacco for his pipe.

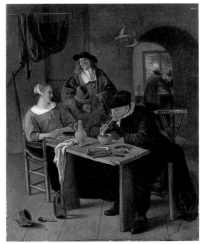

▼ Jan Steen, *While the Old People Sing, The Young Play*, 1663–1665, Mauritshuis, The Hague. This is one of Steen's masterpieces, based on a delicate ambiguity. The work should stigmatize the bad example the old people are setting the young, thus fitting into the moralizing context of Dutch art. The cheerfulness of the scene is unmistakable, however, and includes Steen himself, smiling over his pipe.

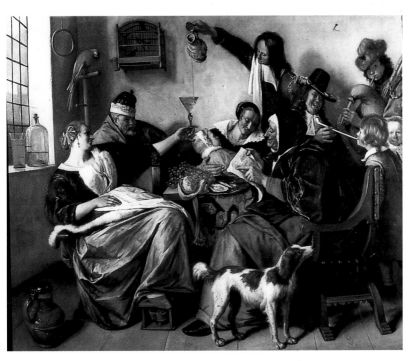

De Hooch: pictures of a serene world

Vermeer's painterly alter ego, although he had none of his flair for intimate scenes and poetry, Pieter de Hooch was also a delicate interpreter of silence, tranquillity, and quiet, clean domestic interiors: the elegance of his works. The delicate balance between perspectival composition, color, and expression make him one of the foremost genre painters of all time. Born in Rotterdam in 1629, de Hooch completed his training with a sojourn in Leiden, where the example of Rembrandt's youthful paintings and the minutely detailed works of Gerrit Dou refined his subtle style. In 1654, he moved to Delft, where for several years he came into direct contact with Vermeer. Both looked to the secret intimacy found behind closed doors, but from different viewpoints. Vermeer always sought out the human and psychological angle of any situation, whereas de Hooch carefully described its external aspects. Prompted by the success he enjoyed among art collectors, de Hooch moved to Amsterdam in about 1663. He died in about 1684, possibly in his birthplace.

▼ Pieter de Hooch, *Interior with Woman Sewing and Child*, 1662–1663, Thyssen-Bornemisza Collection, Madrid. The scene is set in the *vorhuis*, the entrance-hall of 17th-century Dutch houses.

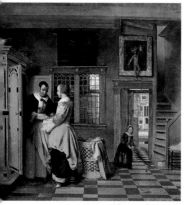

▲ Pieter de Hooch, *The Linen Closet*, 1663, Rijksmuseum, Amsterdam. One of de Hooch's most famous paintings, this work was painted at the end of his Delft period.

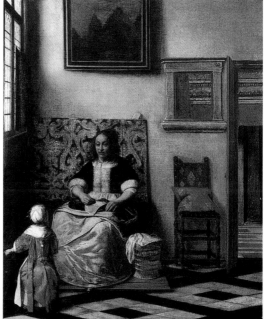

◄ De Hooch frequently painted mothers and daughters, a popular theme in 17th-century Holland, which set great store by the role of mothers in instilling morality and order in their offspring. The tender feelings in these works often overshadow the moral content.

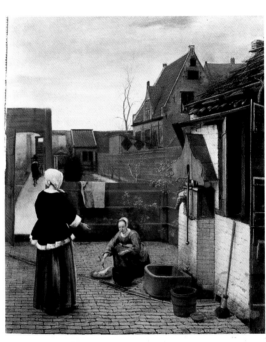

► Pieter de Hooch, *Lady with a Servant in a Courtyard*, c.1660, National Gallery, London. Produced in Delft, this work reveals the artist's great skill in conveying textures and materials.

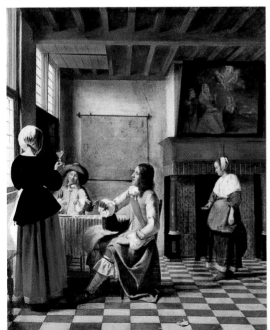

◄ Pieter de Hooch, *An Interior, with a Woman Drinking, with Two Men and a Maidservant*, c.1658, National Gallery, London. The black-and-white chequered floor, its pattern emphasized by the beams on the ceiling, makes it possible for us to work out the accurate measurement of this interior. The carefully worked-out system, which recalls the studies of 15th-century Italian and Flemish painters, enjoyed a renewed popularity in the 17th century, thanks also to discoveries made in physics, optics, and geometry.

A celebration of music

▲ Viola d'amore with mother-of-pearl inlay, Civiche Raccolte d'Arte Applicata, Milan.
The precious mother-of-pearl work resembles the decoration on the guitar played by the girl in the painting opposite.

A keen music lover, Vermeer often painted instruments and players. These scenes are never concerts or public performances but lessons, solitary music practice, or private playing; it is as though Vermeer were saying that music is first and foremost an experience to be enjoyed alone, or, at most, in the company of a very few other like-minded people. Vermeer features a wide range of musical instruments in his paintings, all carefully reproduced, from the spinet to the guitar, the lute to the viola da gamba, the flute to the trombone, which is held with infinite grace by the model who appears in *The Artist's Studio* (p. 121). The technical details and the decorative elements are painted so precisely by Vermeer that it is possible to identify a few "portraits" of actual instruments. This is the case with the famous spinets made in Antwerp by Andreas Ruckers and his heir Jean Cuchet. One of these spinets was purchased in 1648 by Constantijn Huygens for the considerable sum of 300 guilders and it is possible that Vermeer may have had an opportunity to admire the precious instrument at the home of this celebrated intellectual.

▲ Theorbo from the Cremona School, 1593. The lute-manufacturing school in the Italian town of Cremona produced instruments of the finest quality from the late 16th century.

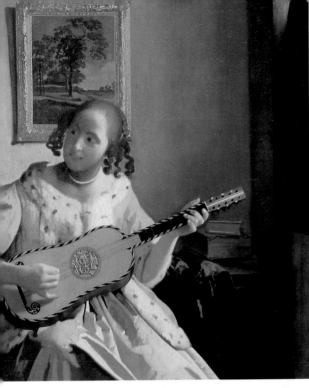

◀ Vermeer, *The Guitar Player*, c.1667, The Iveagh Bequest, Kenwood House, London (English Heritage). Here, Vermeer focuses on the theme of music, and the unusual structure of the painting's composition, with the girl placed off-center, invites the viewer to participate in the scene. The young woman's gaze, turned to one side, seems to suggest this is a musical entertainment involving other people whom we cannot see.

▶ Vermeer, *Woman with a Lute*, 1664, Metropolitan Museum of Art, New York. The girl tuning her instrument is distracted by a ray of sunlight filtering through the window. One of Vermeer's lesser-known works, it is very subtle in its use of chiaroscuro.

◀ Andreas Ruckers, double virginal, late 16th century, Civiche Raccolte d'Arte Applicata, Milan. Spinets and virginals made in Antwerp by Ruckers were famous throughout Europe, not only for their excellent quality but also for their sumptuous decoration.

The Music Lesson

Part of the Royal Collection, St James's Palace,
London, this painting dates from about 1664.
It was part of the collection of the English
consul Joseph Smith, and was purchased by
King George III in 1762 as the work of van Mieris.

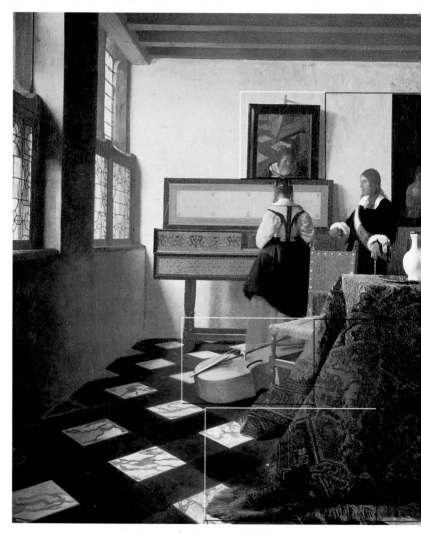

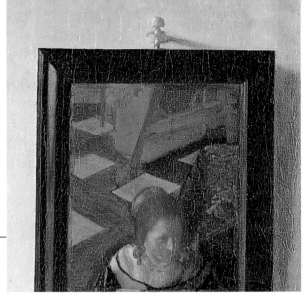

◄ The reflection in the mirror reveals all the tender concentration in the girl's expression but, interpreted on an allegorical level, can also be seen to refer to the feelings that may be burgeoning within the couple. The figures are separated by tangible objects, such as the back of the blue chair, but they are connected by the harmony of the music.

► Vermeer paints the cello with extreme care; the warm shades of the wood are faithfully reproduced and the spinet bears the inscription: "MUSICA LAETITIAE COMES MEDICINE DOLORUM" ("Music is the companion of joy and a medicine for suffering").

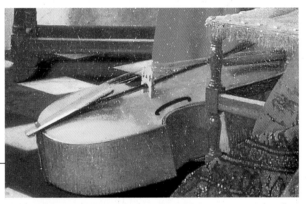

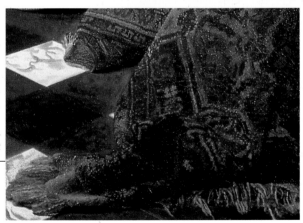

◄ The clearly drawn, minutely detailed instrument is in contrast with the painting's foreground, which has been left deliberately vague. The drapery covering the table falls in crumpled folds to cover part of the geometrically tiled floor, which is rendered with great perspectival skill.

LIFE AND WORKS

Vermeer's sources

► Rembrandt,
Concert in Biblical Garb,
1626, Rijksmuseum,
Amsterdam. This is
one of Rembrandt's
early works, painted
when he was still
influenced by the
preciosity of Leiden's
"fine painting". The
figures are enveloped
in an exotic atmosphere,
which is emphasized
by the singer's musical
accompaniment, a viola
da gamba and a zither.

The presence of players and musical instruments in Vermeer's works prompts an enquiry into the Delft artist's cultural references. Although the originality of his lyrical and psychological interpretations is unquestionable, it is worth remembering that music was one of the most frequently recurring themes in Baroque painting, both in Holland and elsewhere, whether in the form of still lifes or individual or group portraits of musicians and singers. We know that in some cases, famous painters were also talented musicians, and music and painting entered into a kind of friendly competition, colored by a mutual exchange of ideas. Artists sought "harmony" in their compositions and musicians "color" effects in their playing. The traditional Renaissance relationship between painting and poetry was turned in the 17th century into a dialogue between painting and music. Music was so widespread a subject in European art that we cannot name Vermeer's "predecessors" with any certainty, although we know that he was influenced by Flemish–Dutch art and Italian art in equal measure.

► Caravaggio, *The Lute Player*, 1596–1597, Metropolitan Museum of Art, New York. The relationship between Caravaggio and music is a close one: the artist was well versed in musical theory and even included clearly legible scores in some of his youthful works.

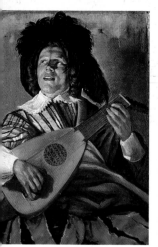

▲ Judith Leyster,
Serenade, 1629,
Rijksmuseum,
Amsterdam. Leyster
often included musical
references in her portraits
and genre scenes.

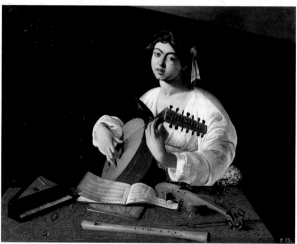

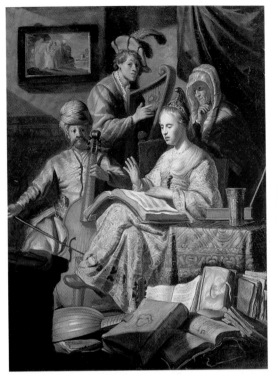

▼ Jan Steen, *Two Men and a Young Woman Making Music on a Terrace*, c.1663, National Gallery, London. Steen's treatment of the musical theme is gentle and delicate. The luminous young girl appears fragile compared with the solidity of the spinet.

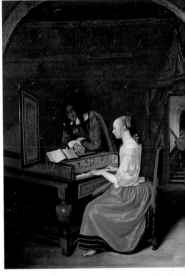

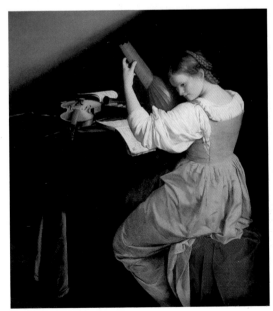

◄ Orazio Gentileschi, *The Lute Player*, 1610, National Gallery, Washington, DC. In this painting, a young girl competently tunes her instrument.

BACKGRθ

Delft pottery and Oriental ceramics

Delft's worldwide renown is thanks chiefly to its pottery. The manufacture of faïence pottery in the Dutch town dates from the 14th century, but its period of greatest development occurred in the 17th and 18th centuries, when the city began to compete, often successfully, with the elegant but highly expensive ceramics that were imported from the faraway Orient. While European collectors acquired a taste for Chinese or Japanese wares, Delft produced its distinctive white and blue ceramics, catering for a wide range of commercial outlets. Objects included vases, bowls, and plates, their shape imitating the Oriental style, as well as small square tiles decorated with geometric patterns, landscapes, bouquets of flowers, battle scenes, and seascapes that could be assembled to produce impressive and monumental effects. These were destined for interior decoration, in much the same way as the Portuguese and Brazilian *azulejos* that date from the same time. In the 18th century, the first European porcelain to be manufactured in Europe marked the beginning of the end for Delftware, which continued to be produced until 1860.

▲ Vermeer, *A Young Woman Standing at a Virginal*, c.1670, detail, National Gallery, London. The skirting board in this painting is decorated with a row of Delft tiles, decorated with figures and soldiers inspired by the picaresque engravings of Jacques Callot.

▼ Delftware vases in the Chinese style, Musée National de la Céramique, Sèvres.

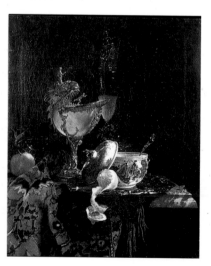

◀ Willem Kalf, *Still Life with Nautilus Goblet*, Thyssen-Bornemisza. Collection, Madrid. This is one of the most famous and elegant still lifes from Holland's "Golden Age". All the objects portrayed are rare and expensive, including the fruit. Dominating the picture is a magnificent Oriental china bowl, a product that would have had a very high commercial value in its day.

▼ The kitchen at the Amalienburg hunting lodge, designed by François de Cuvilliés, in the grounds of the Nymphenburg Palace, Munich.

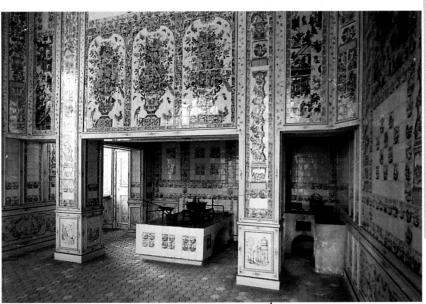

Ceramics in furnishing decoration

Set in the luxuriant parkland surrounding the Nymphenburg Palace, the tiny Amalienburg hunting lodge is a jewel of the European Rococo. Although conceived as a hunting lodge, it is a beautiful villa in its own right. The decoration of the kitchen, which is covered with thousands of blue and white tiles, marks the apotheosis of Delftware manufacture and is one of the most impressive examples of this type of ornamentation.

Revealing details

The stress laid on the symbolic aspects of Vermeer's art may appear to be excessive. Anyone viewing the Delft artist's work today will be intrigued by its psychological aspects or by the stirring description of interiors achieved by means of color and light. It must not be forgotten, however, that Vermeer's life and work was played out against the well-documented cultural background of 17th-century Holland. A typical feature of the time was the custom of burying concealed meanings even in the most seemingly innocent and banal scenes. One of the Dutch government's most powerful drives in the 17th century was to increase literacy levels and in order to stimulate an interest in reading, many heavily illustrated books were published that were both popular and cheap. Collections of emblems, word games, and mottos were immensely popular and these slender volumes are evidence of a predilection for allegorical references, hidden meanings, and the connection between an image and a concept. Although Vermeer consciously worked within this climate, apart from in the explicit *Allegory of Faith* he deliberately left underlying references blurred and ambiguous. We can thus interpret the descriptive details of his paintings in many different ways, which only adds to the appeal of his work.

◄ Vermeer, *Woman with a Water Jug*, 1664–1665, Metropolitan Museum of Art, New York. The jug may be interpreted in a number of ways: as a symbol of temperance, as an instrument of cleanliness (both physical and moral), and as a sexual reference.

▶ Judith Leyster,
The Young Flute Player,
Nationalmuseum,
Stockholm. The power
of music, expressed by
the boy's concentration,
overcomes poverty,
suggested by the
broken chair and
the torn sleeve.

▶ Vermeer, *Girl
Reading a Letter
at an Open Window*,
c.1657, Gemäldegalerie,
Dresden. We will never
know the contents of
the letter and can only
sense the feelings that
are coming to the fore
in this silent room.
The skilfully rendered
reflection of the girl
in the glass window
panes may help
us in our surmises.

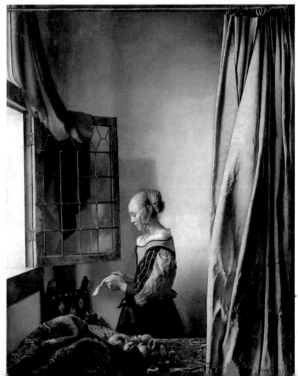

85

Genre painting or subtle symbolism?

It is technically correct, if we must give Vermeer a label, to define him as a genre painter like his fellow artists and friends Steen, de Hooch, and Ter Borch. This is because the subjects he chooses (apart from the youthful paintings) are not inspired by memorable historical religious, or mythological events, but are firmly bound up with simple situations set in everyday backgrounds and peopled by anonymous figures, who have no past of which we can be aware but are full of humanity and poetry. This categorization is, however, balanced by the depth of content found in his work. Paintings by Vermeer, like those by his contemporaries, may be viewed at face value, as scenes drawn from everyday life. They can also, however, reveal a rich tapestry of allegorical references that enriches them and makes their meaning more complex. Ever since Brueghel and Bosch, Flemish–Dutch art has revelled in this sophisticated set of codes, which is all the more effective when gestures and objects appear to be casual. With Vermeer, the truth is never what we see on the surface.

▲ Sebastian Stosskopf, *Summer*, 1633, Musée de l'Oeuvre de Notre-Dame, Strasbourg. This is one of the rare masterpieces of the great Alsatian painter. The objects portrayed refer to the five senses: the violin to hearing, the flowers to smell, the peaches to taste, the mirror to sight, and the chess pieces to touch. Each of these objects, however, can also be interpreted quite differently, producing an almost metaphysical sense of ambiguity.

▲ Frans van Mieris, *Brothel Scene*, 1658, Mauritshuis, The Hague. The sexual reference implicit in the wine being poured into the glass is confirmed by the copulating dogs.

◀ Jan Steen painted many different versions of this subject, parodying the love-sick woman being visited by a physician.

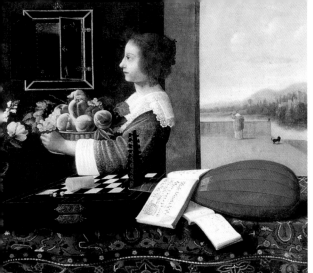

▼ Vermeer, *Woman with a Water Jug* 1664–1665, Metropolitan Museum. of Art, New York. Among the many possible interpretations of this painting is the notion of an allegory of the Dutch nation, casting her gaze beyond her restricted territorial confines towards wider sea routes. Any allegorical readings, however, falter before the simple domesticity of the scene.

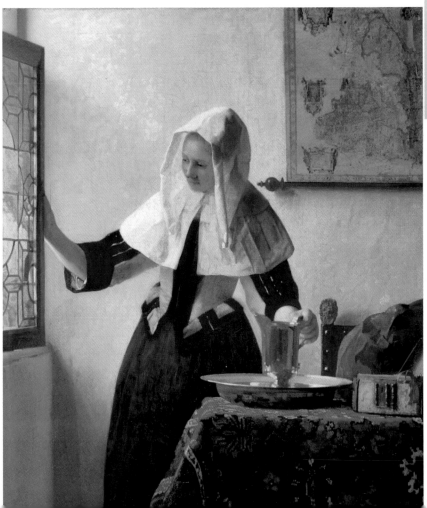

Woman with a Pearl Necklace

Dating from about 1665, this painting is now in the Gemäldegalerie, Berlin. It is one of several scenes of ladies at their toilet that were popular in Dutch art after the mid-17th century.

▲ Light filters through a window, a favorite pictorial device of Vermeer's. The ray of light is pale and toned down in comparison to his other works. The room is bathed in a delicate golden light, with the drapery and the girl's gown evoked in skilfully rendered yellow tones. This is the most effective light in which to show the softly gleaming string of pearls.

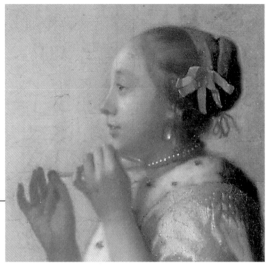

▲ The expression of the girl, who is admiring her reflection in a small mirror hanging by the window, is one of satisfaction and astonishment, as though she were wearing the necklace for the first time. Vermeer hints at her feelings with delicate subtlety, without sacrificing any symbolic undertones.

▼ The toilet accessories on the table make up a splendid still life. They can be viewed as a moral reference to vanity, earthly goods, and pride, while the pearls, conversely, suggest purity, virginity, and faith.

Dutch moralism

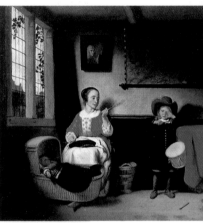

▼ Nicolas Maes, *The Mischievous Drummer*, 1654–1659, Thyssen-Bornemisza Collection, Madrid. This delightful scene was drawn from the artist's own family life: his wife reprimands her firstborn, who beats his drum and is in danger of waking up his infant sister in the crib.

The allegorical interpretation of Vermeer's tantalizingly ambiguous works links them to the Dutch artistic culture of the period. The Dutch government developed a veritable "pictorial strategy" in order to drive home notions of national identity with the utmost impact. Works of art were widespread and not intended just for the homes of the more affluent. They penetrated deep within the middle class, too, offering a wide-ranging expression of moral concepts, civil customs, and domestic situations in which all citizens could – and indeed were expected to – recognize themselves. Although Vermeer's paintings are never markedly didactic or moralistic in tone, they can certainly be interpreted as part of the overall mood of 17th-century Dutch society, the product of a young country's need to communicate its values and aspirations through its art.

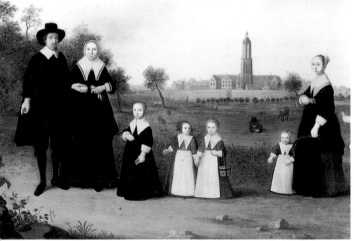

◄ Cornelis Wilaertl, *Family Group near Rhenen*, Sforza Castle, Milan. Modest in style, this painting is an unmistakably effective historical and visual document. The dignified composure of the figures, the austere moralism they convey, and the hierarchy of the individual domestic roles make this the portrait of a model Dutch Calvinist family.

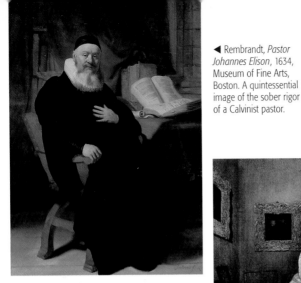

◄ Rembrandt, *Pastor Johannes Elison*, 1634, Museum of Fine Arts, Boston. A quintessential image of the sober rigor of a Calvinist pastor.

▼ Gerard Ter Borch, *Woman Washing her Hands*, c.1655, Gemäldegalerie, Dresden. A quiet, everyday life and habitual – although not insignificant – gestures are favorite themes in Ter Borch's elegant works.

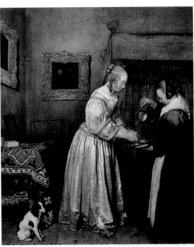

▼ Jan Steen, *The Happy Family*, 1668, Rijksmuseum, Amsterdam. The family portrayed here is no model of order and discipline. Confusion and uproar dominate the house. This work should be morally critical in tone, but it suggests instead a sense of amused complicity between the generations, from the boisterous old man raising his glass to the chubby baby holding up a spoon.

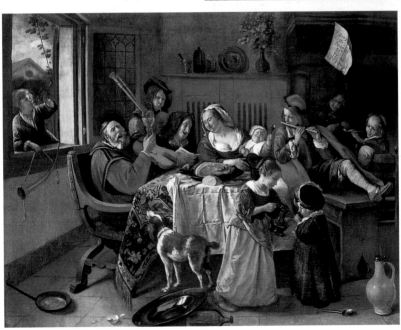

The influential role of Constantijn Huygens

The image of Vermeer as an isolated and unknown painter has been refuted by recent studies, which have revealed a series of high-ranking contacts and, most significantly, a friendship between the Delft artist and Constantijn Huygens (1596–1687), an intellectual and politician of considerable influence. Secretary to the *stadhouder* Frederich Henry of Orange, Huygens dominated Dutch cultural life over a long period of time. It was quite likely he who suggested a visit to Vermeer's Delft studio to the French diplomat Balthasar de Moconys in 1663, and who put the wealthy Pieter Teding van Berckhout (who was related to the Huygens family) in touch with the artist. Van Berckhout's diary records two separate visits to Vermeer's studio, in May and June of 1669. On the first occasion, he describes Vermeer as "*excellent*" and on the second as "*célèbre*", which gives an idea of the the artist's increasing fame and reputation, particularly within Huygens' intellectual circle.

▲ Jan Lievens, *Constantijn Huygens*, 1628–1629, Rijksmuseum, Amsterdam. Although he admired Rembrandt, Huygens chose the artist's partner Jan Lievens to paint his portrait.

▲ Dutch artist of the second half of the 17th century, *Portrait of Christiaan Huygens*, het Trippenhuis, Amsterdam. Constantijn's son Christiaan was one of the foremost physicists of his day.

◄ Rembrandt, *Portrait of Maurits Huygens*, 1632, Kunsthalle, Hamburg. The account of Huygens' visit to the studio of Rembrandt and his partner Jan Lievens in Leiden is legendary. Huygens was the first to discover the talent of the "young and talented painters". His praise was decisive in launching their fame. Lievens moved to England and Rembrandt to Amsterdam. Huygens commissioned Rembrandt to paint this portrait of his brother.

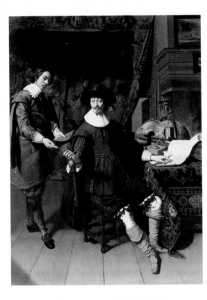

◄ Thomas de Keyser, *Constantijn Huygens and his Clerk*, 1627, National Gallery, London. Holland's ambassador to Venice and London respectively, Huygens corresponded with Descartes and was receptive to both classical culture and scientific study. He embodied to perfection the European Baroque concept of "modern man".

▼ Rembrandt, *The Blinding of Samson*, 1636, Städelsches Kunstinstitut, Frankfurt. One of Rembrandt's greatest and most dramatic masterpieces, this work was painted as a personal gift to Constantijn Huygens to thank him for his constant support throughout his career.

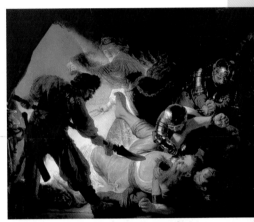

▼ Rembrandt, *Diana Bathing*, 1634, Wasserburg Anholt Museum, Anholt. A tireless traveller and a classical poet in his own right, Huygens was concerned with raising the tone of Rembrandt's subject-matter and widening his literary culture (the artist had been an indifferent pupil at the Latin School in Leiden). He commissioned canvases with mythological themes, forcing the young Rembrandt into humanist studies.

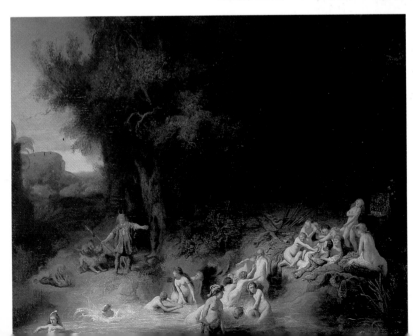

A passion
for geography

Elaborate geographical maps and globes can be included among the most typical details that feature in Vermeer's paintings. Vermeer reproduces these objects, which may have an underlying allegorical meaning, with extreme precision, revealing a considerable personal knowledge. In this respect, as in so many others, his paintings can be viewed not as the work of an isolated artist but in strict connection with the culture of his day. Like most Dutch people, Vermeer travelled only rarely, limiting his journeys out of Delft to nearby towns or, at most, to Amsterdam. He shared the national pride in those seafaring heroes, admirals, and navigators who had made Holland a mighty colonial power through their faraway travels across the ocean routes. For Vermeer and 17th-century Dutch society as a whole, accounts of exotic voyages, the opportunity to observe maps, and a desire to embrace even the remotest continents in one's mind held a powerful appeal and were combined with the pleasure derived from keeping an orderly house – striking a balance between the vastness of the world at large and one's own, immediate, limited living space.

▼ Jodocus Hondius, globe of the world, 1613, Museo di Storia della Scienza, Florence. Active in Amsterdam. The most famous maker of terrestrial and celestial globes in Europe in the early 17th century, Hondius based his work on studies by the Danish astronomer Tycho Brahe and accounts by navigators and mathematicians.

◄ Telescopes and helioscopes in an illustration to *Rosa Ursina* (1630), a treatise by Christoph Scheine. Scientific instruments held a magical, evocative power in Baroque imagery. Vermeer, on the other hand, reduces their extraordinary elements to a minimum, concentrating more on their intellectual aspect.

◄ Flemish astrolabe, 16th century, Kunsthistorisches Museum, Vienna. Many impressive precision instruments were manufactured in Flanders and Holland.

▼ Vermeer, *The Astronomer*, 1668, Musée du Louvre, Paris. An obvious companion to *The Geographer* (pp. 96–97), this may originally have been conceived as one of a pair of paintings.

The figure here is engrossed in the study of a celestial globe. The intellectual link between the mind and the hand is power-fully expressed, with Vermeer celebrating both culture and the senses.

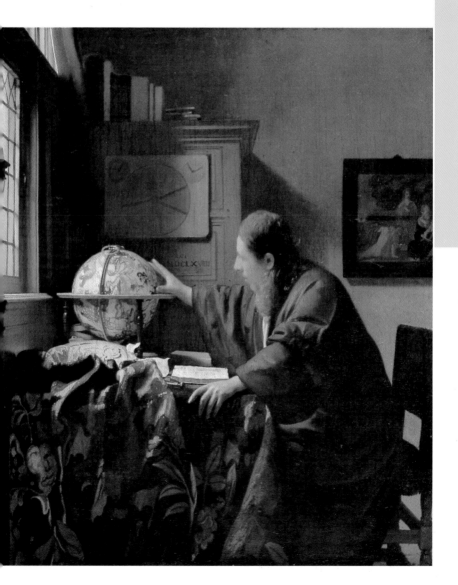

1665–1670

The Geographer

The date – 1668 – inscribed on the wall and the signatures next to it and on the cupboard are not original. The painting, one of the few in which Vermeer portrays a single male figure, is housed in the Städelsches Kunstinstitut, Frankfurt.

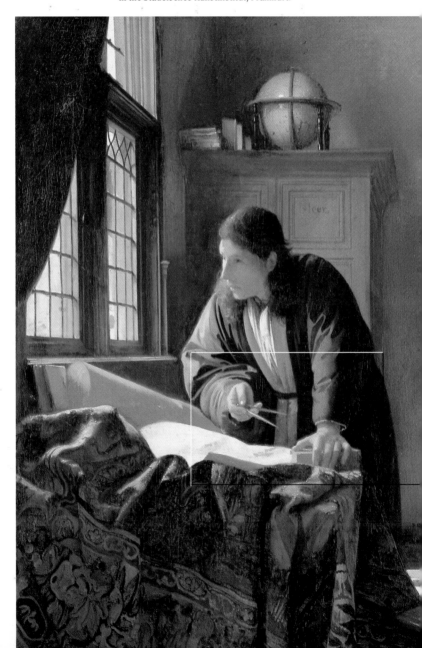

◀ H. van der Mij, *Jan and Pieter van Musschenbroek*, Museum Boerhaave, Leiden. The brothers were famous scientific researchers and makers of precision instruments. Their work table provides us with a realistic picture of the instruments available in Baroque Holland. The painting, of scant artistic merit, is of purely documentary interest.

▼ The figure in Vermeer's painting is captured in a moment of intense concentration: he lifts his eyes up to the light while his hands, one on the map and the other holding a compass, are frozen, almost as if waiting for the mind to guide them. Although there is no documentary background to the work, many have seen an idealized self-portrait of Vermeer in the intense expression of the young man.

▲ Joseph Wright of Derby, *A Philosopher Giving a Lecture on the Orrery Exhibition*, 1766, Museum and Art Gallery, Derby. Eighteenth-century England was also fascinated by pictures with a scientific theme.

Science and art

The relationship between painting and science is important to our understanding of Vermeer's art and, more generally, to the cultural climate in 17th-century Holland. Ever since Descartes moved to Amsterdam in 1628, the study of various areas of science and the philosophies associated with them became a fundamental feature of Dutch thought. Thanks to widespread popular publications, concepts of physics, geography, astronomy, medicine, and mathematics were available to the general public, while the manufacture of precision instruments in cities such as Leiden and Delft itself came to play a significant role in the local economy. The pursuit of scientific knowledge was, of course, a further drive on the part of the United Provinces, ever in pursuit of progress and ways in which to proclaim its independence and identity, to keep abreast of developments in learning and to define itself. Vermeer's connection with van Leeuwenhoek illustrates the marriage of painting and science that was typical of the time, although, even without this biographical background, it is clear that his paintings reveal a careful attention to precision instruments. Vermeer also painted memorable pictures of scientists at work, the intensity of their concentration mirroring his own unwavering meticulousness in achieving perfection.

▲ The principle of the camera obscura is here illustrated by Caspar Schott in his *Technicae curiosae*, a popular scientific treatise published in Würzburg in 1687.

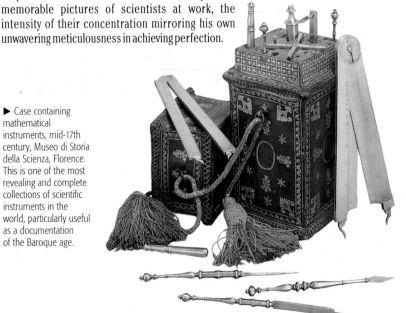

▶ Case containing mathematical instruments, mid-17th century, Museo di Storia della Scienza, Florence. This is one of the most revealing and complete collections of scientific instruments in the world, particularly useful as a documentation of the Baroque age.

▲ Vermeer, *The Geographer*, detail, 1668, Städelsches Kunstinstitut, Frankfurt. The terrestrial globe and the books on the shelf point to Vermeer's interest in scientific instruments. He paints useful and precise objects, not a set of extravagantly bizarre instruments and precious materials. The aesthetic worth of these objects is basically irrelevant compared with their usefulness.

◄ In the 17th century, Dutch still lifes often included globes, hourglasses, measuring instruments, and much-thumbed old scientific books. The world of science entered into a meaningful dialogue with art and, most of all, satisfied a new curiosity among the educated public to know more about matters scientific. European collectors liked to show their modernity not only in art but, more generally, by expressing an intellectual interest in a whole range of different disciplines. Dutch artists were masters at this specific type of still life, although other countries, too, began to display a very similar artistic inclination.

99

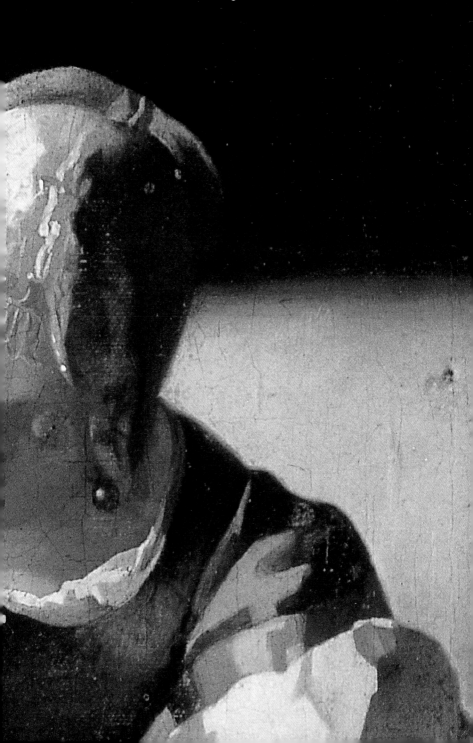

The final years

LIFE AND WORKS

A new social status

▶ Cornelis de Man, *Group Portrait in the Chemist's House*, c.1670, Muzeum Narodowe, Warsaw. The noble stance of the figures portrayed expresses all the complacency of an emerging intellectual and scientific group that was part of the upper class in 17th-century Holland. The highest social class was solidly made up of merchants and businessmen, but even those who were employed in the arts and crafts – especially those who provided materials for manufacture – were part of the elite.

From 1669, Vermeer's life and career appear to be more clearly defined. Many intellectuals and influential figures visited his studio; in 1670, the Guild of St Luke elected him syndic for the second time; and in 1672, having inherited a modest sum on the death of his mother and sister Gertruijt, he decided to rent out the Mechelen inn and devote himself exclusively to painting. Previously, he had always combined painting with his inn-keeping duties and the art-dealing business that had been established by his father. Also in 1672, he was summoned to the court at The Hague together with Johannes Jordaens to value some Italian paintings that had been considered to be masterpieces but turned out to be worthless and devoid of any artistic merit. Vermeer, now nearing 40, wanted to establish himself professionally within the context of an affluent bourgeois and intellectual social class. Maintaining his wealthy lifestyle would prove to be particularly difficult, however, both for the artist (who borrowed heavily in order to achieve his aim) and for his unfortunate widow, who, after Vermeer's untimely death, was faced with crippling debts and forced to become embroiled in arduous legal battles.

▼ Dirck van Bleyswyck, *The New Town Hall in Delft*, engraving, detail, 1667. Built in 1620 around an existing 14th-century tower, the Town Hall is Delft's main Baroque monument. It was built by Hendrick de Keyser, who also completed the tomb of William the Silent in the Niuewe Kerk at about the same time.

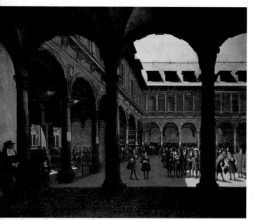

◀ Jacob Berckheyde, *The Courtyard of the Stock Exchange at Amsterdam*, Historisch Museum, Amsterdam. The Stock Exchange was the nerve center of all commercial activity in 17th-century Holland.

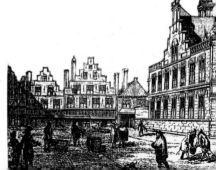

▶ Jan Miense Molenaer, *The Harpsichord Player*, Rijksmuseum, Amsterdam. Although it is no longer believed to be a portrait of the artist's wife and children, this painting provides a glimpse of a typical middle-class domestic interior of the period.

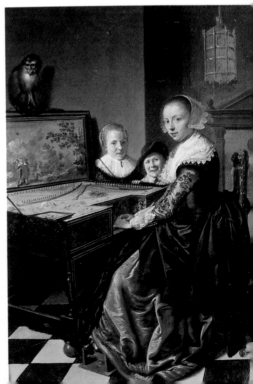

A scientist friend

▼ English microscope dating from the late 17th century covered in leather and elegantly embossed with gold.

Antonie van Leeuwenhoek, a gifted scientist, prominent figure in Delft, and personal friend of Vermeer, played an interesting role in the artist's life just before his premature death and was involved in the painful events that were to follow it. The thorny task of winding up Vermeer's estate, and dealing with the legal consequences of the bankruptcy that his widow was unable to avoid, fell to van Leeuwenhoek. A fellow citizen and neighbor of the artist, van Leeuwenhoek was a moderately successful cloth merchant, but his real passion was the making of scientific instruments. Self-taught, he was extremely skilled at making lenses, producing hundreds of examples. By ingeniously assembling and combining different lenses, he was able to put together the first microscopes that could enlarge objects up to 500 times. An immensely patient man with a keen eye and a fertile mind, van Leeuwenhoek was the first to make certain fundamental observations in anatomy and zoology: taking the study of insects and then of human spermatozoa as his starting point, he made a significant contribution to the definite rejection of the theory of spontaneous generation. His observations, submitted by letter to the Royal Society in London from 1673, turned the amateur scientist into one of the most famous scientists in Europe and earned him the membership of leading English and French institutions.

▶ A set of microscope lenses, c.1690, built by Jan van Musschenbroek in Leiden. The production of precision instruments was the jewel in the crown of Dutch manufacture.

◄ Jan Verkolje, *Portrait of Antonie van Leeuwenhoek*, Rijksmuseum, Amsterdam (on loan from the Science Museum, Leiden). This portrait of the famous microscope maker was well-known through copies and engravings.

▼ The treatises on optics and microscopy published in the 17th century feature instruments very similar to the few, intricate examples that can now be viewed in science museums. The tube is usually covered in embossed leather.

▲ Title page of a treatise on insects by Francesco Redi, published in Amsterdam in 1686. Here, the allegorical image of Science studies the world of nature through a pioneering miscroscope.

◄ Jan van der Heyden, *Interior of a Library*, 1674, Thyssen-Bornemisza Collection, Madrid. Famous most of all for landscapes and views, van der Heyden in his later years also painted interiors featuring scientific instruments.

Perspective

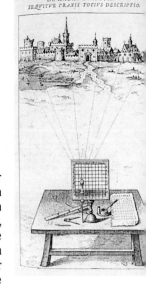

In his later works, Vermeer stressed the complexity of perspectival structures to an even greater degree than before. In many cases, the main scene is viewed from another room; the viewer is, ideally, placed in a shadowy environment and separated from the area in which the figures are located by an opening with heavy drapery, which is almost a partially raised theater curtain. The arrangement of the spaces into a successive series and the harmonious proportional placement of each detail show us that Vermeer was fully versed in the rules of projective geometry and perspective. The wide availability of studies and treatises on optics and perspective published in many European countries, including Holland, during the 17th century provided painters with constant opportunities for updating their knowledge in this field. It is likely, however, that Vermeer used technical instruments and systems for his reproduction of domestic interiors. Many Dutch artists of this period are known to have used the camera obscura, including Jan van der Heyden, who had independently developed a model of his own in order to paint urban views. The public in the Netherlands were particularly exigent in their requirements for precise townscapes.

▲ A treatise by Fludd, published in Oppenheim in 1617 and illustrated with many practical suggestions for artists, was of particular importance to the use of perspective in 17th-century paintings.

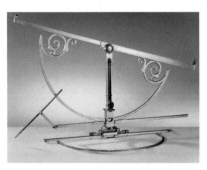

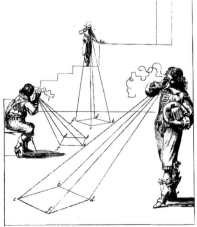

▲ Instrument for perspectival drawing, in brass and iron, built in Kassel, Germany, in 1604, Kunsthistorisches Museum, Vienna. Antique scientific objects are extremely elegant and almost artistic in their design.

◀ Cornelis Gysbrechts, *The Back of a Painting*, c.1670, Statens Museum for Kunst, Copenhagen. A triumph of 17th-century *trompe l'oeil* and surprisingly modern in style, this work demonstrates the wealth of themes and subjects treated by Dutch artists during the "Golden Age".

▶ Jan Steen, *The Morning Toilet*, 1663, Royal Collection, Windsor. Although it appears on the surface to be based on a traditional compositional structure, this painting is actually a small theorem of applied geometry, handled by Steen with his typical, amused participation. A few objects are placed on the threshold of the classical doorway, including a lute. The tiled floor and canopied bed create a sense of depth.

◀ Sight radius in an illustration from a treatise on perspective by Abraham Bosse, published in Amsterdam in 1684.

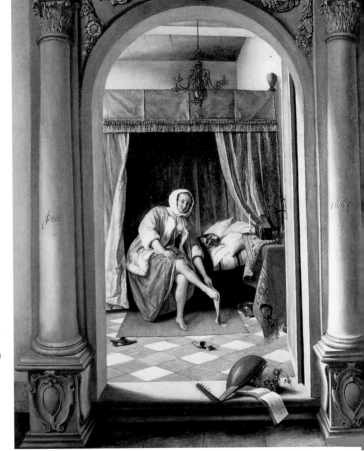

The Love-letter

Now housed in Amsterdam's Rijksmuseum, this painting dates from about 1669. The maid's smiling expression and the serene landscapes hanging on the wall suggest a happy conclusion to the love story connected with the letter.

▼ Vermeer uses an extremely effective perspectival device in this painting. A parted curtain enables the viewer to glimpse the scene beyond what appears to be a slightly untidy anteroom. The faultless application of the rules governing the definition of space and depth is emphasized by an experienced use of light and by the inclusion of domestic artefacts such as the linen basket. This is illuminated by the ray of sunlight filtering through an unseen window.

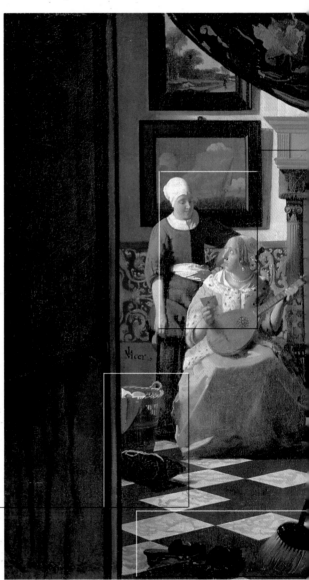

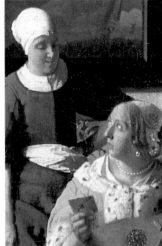

◀ The relationship between the two women, based on looks, feelings, and feminine complicity, crosses the social divide that separates them. The lady looks worried about the contents of the letter, whereas the maid, who may already know what it says, looks at her reassuringly. A calm sea, as can be seen in the painting behind the women, is a traditional Dutch symbol of requited love.

▶ Pieter de Hooch, *Couple with a Parrot*, 1668, Wallraf Richartz Museum, Cologne. Vermeer was almost certainly inspired by this painting for the unusual use of perspective in his composition.

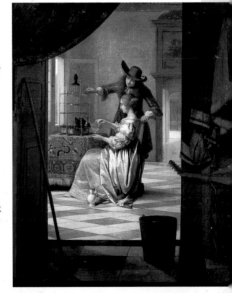

▼ The broom and slippers in the foreground point to the routine tasks of everyday life. They mark the boundary between the dark anteroom where the viewer appears to be and the luminous room in which the scene is set.

An expert at The Hague

Given the scarcity of major episodes in an uneventful life such as Vermeer's, a journey to The Hague, which was just a short distance from Delft, becomes a memorable occurrence. On May 23, 1672, when he was just a few months short of his 40th birthday, the artist was summoned by the court of James Maurice, Count of Nassau-Siegen, to carry out an artistic task. Although the request was a great honor, it was one that he shared with a painter scarcely remembered nowadays, his compatriot Johannes Jordaens (not to be confused with the talented Flemish artist Jacob Jordaens). Vermeer and Jordaens were asked to value a collection of 12 Italian paintings, believed to be genuine masterpieces. It is clear that Vermeer was regarded as an authority on international painting, which underlines the importance of his father's art-dealing activities in nurturing his art expertise. The outcome of the mission was a disappointment, however: Vermeer and Jordaens unhesitatingly denounced the 12 canvases as poor, ugly copies and confirmed this opinion before a notary.

▲ The painting gallery of Prince William V, Buitenhof, The Hague. The gallery has maintained the character of a princely collection from the Baroque age, with paintings crowded next to one another in rows. Open to the public as early as the 18th century, this is the oldest museum in Holland.

◀ Jan de Baen, *Portrait of John Maurice of Nassau*, c.1660, Mauritshuis, The Hague.

▼ This drawing of The Hague by Jan van Call, dating from about 1690, shows the Huygens family home in the foreground, on the left, and, further back, the Mauritshuis, the residence of John Maurice, Count of Nassau-Siegen.

▲ Gerrit van Honthorst, *Prince William III as a Child with his Aunt Mary of Nassau*, 1653, Mauritshuis, The Hague. Van Honthorst held the position of court painter for many years.

◄ Gerrit Berckheyde, *View of the Binnenhof at The Hague*, c.1690, Mauritshuis, The Hague. The residence of the Orange court overlooks the Hofvijver and is at the heart of The Hague's historic town center.

► Bartholomaeus Eggers, *Bust of John Maurice of Nassau-Siegen*, 1664, tomb of the counts of Nassau-Siegen. This bust was originally in the inner garden of the Mauritshuis, which was designed in 1668 by Maurits Post. It was later placed on John Maurice's tomb.

111

The Lacemaker

Housed in the Louvre, this is one of Vermeer's best-known paintings and an exception among his genre scenes: the girl is shown in close-up, in contrast to the more complex perspectival treatment favored in his other interiors.

▲ Marten van Heemskerck, *Portrait of a Woman at a Spinning Wheel*, 1529, Thyssen Bornemisza Collection, Madrid. This is an interesting earlier work on the theme of female occupation; the artist seems to be more interested in the complicated structure of the spinning wheel than in the expression of the woman.

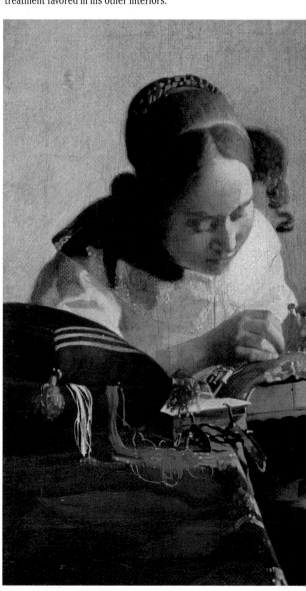

▶ Attributed to Pieter de Hooch, *Woman Sewing*, Niedersächsisches Landesmuseum, Hanover. This painting was sold several times in the 18th century as the work of Vermeer, despite it being of unremarkable quality. This tells us how, a century after his death, his work came to be grouped with inferior works of similar subject-matter.

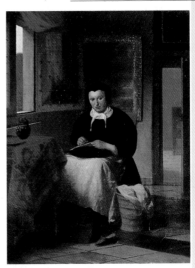

◀ Diego Velázquez, *The Needlewoman*, 1641, National Gallery, Washington, DC. A comparison of Vermeer's *Lacemaker* with a similar work by Velázquez highlights Vermeer's meticulousness and his patient treatment of light and details. This is in sharp contrast to the broad, quickly executed brushstrokes of Velàzquez, whose painting looks unfinished.

▶ Caspar Netscher, *The Lacemaker*, 1664, Wallace Collection, London. Dutch 17th-century painting abounds with beautiful pictures of solitary young girls concentrating on their sewing or lacemaking.

113

Debts and money worries

Although Vermeer did not have to endure the public humiliation of financial ruin, a fate that cruelly befell Rembrandt, his own monetary situation was far from healthy. His name appears with some frequency in legal documents granting him loans and the idea of renting out the family inn the Mechelen did not prove to be as successful a business venture as he might have hoped. It must be remembered, however, that loans were by no means an unusual feature of the economy in 17th-century Holland and it is therefore difficult fully to assess the artist's capital and financial affairs. We do know that he produced few paintings, working very slowly, he was not connected to any patron or art dealer, and he demanded rather high prices for his works. Although he was not an unknown artist and was repeatedly praised in art writings and travellers' accounts, the marginal geographical position of Delft did little to favor his career.

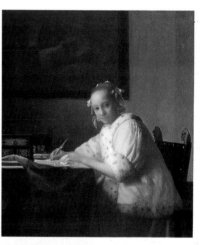

◀ Rembrandt, *The Portrait of the Syndics of the Clothmakers' Guild*, 1662, Rijksmuseum, Amsterdam. Immortalized in this memorable late masterpiece by Rembrandt, the five syndics of the clothmakers' guild are consulting a book of samples and working out the price of fabrics. The Dutch economy was strictly managed and linked to guilds such as this one.

◀ Jan Steen, *The Drawing Lesson*, 1663–1665, J. Paul Getty Museum, Malibu. Taking on paying pupils earned artists a modest income, but there is no evidence that Vermeer ever gave lessons or kept a workshop with apprentices.

▼ Vermeer, *Mistress and Maid*, c.1667, Frick Collection, New York. The slight concern in the lady's expression can be seen as a polite reference to the money worries that now began to plague the Vermeer family.

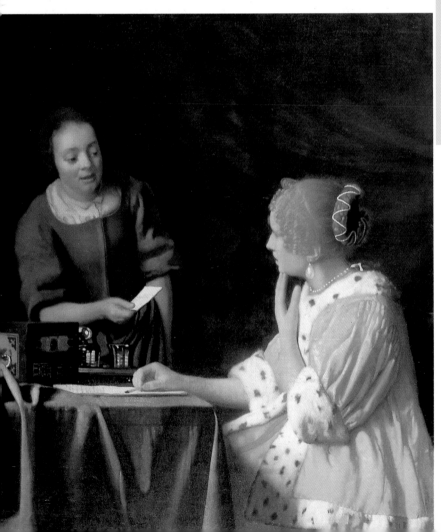

A Young Woman Seated at a Virginal

Although similar in date, subject, and format to *A Young Woman Standing at a Virginal* (both are housed in London's National Gallery), the two were in fact not conceived as a pair.

▼ The detail below shows the elegant execution of the different surfaces: the legs of the virginal are of shiny varnished wood, painted to look like marble, and the light lingers over the warm, smooth texture of the viola da gamba, a magnificent "portrait" of this musical instrument.

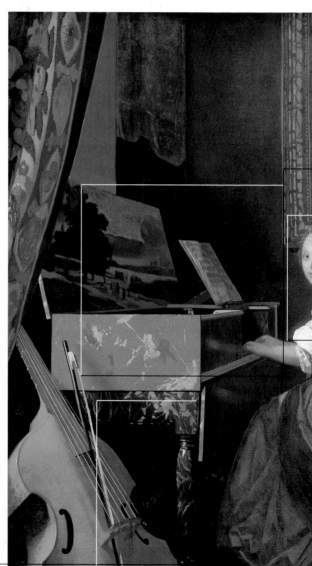

▲ The virginal is painted with great care. It is a prestigious, lavishly decorated instrument, similar to those produced by Andreas Ruckers and his successors. This work may have been commissioned by the Antwerp collector Diego Duarte, an expert in musical instruments.

▼ The girl looks questioningly at us as if waiting for a comment, a device that makes the viewer feel directly involved in the work. The contrast between the sense of moderation that hovers over the painting and the lewd subject of the "painting within a painting" on the wall is a powerful one.

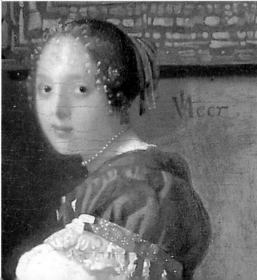

The development of the Dutch art market

Despite the widespread affluence and considerable social standing of potential art buyers, life was not easy for Dutch painters in the 17th century. Besides a great deal of rivalry among themselves, which was only partly controlled by protective measures set up by the local guilds, artists had to contend with the ever-changing vagaries of international fashions, which caused quite dramatic turns in taste, beginning in Amsterdam (the country's most flourishing art market) and rapidly spreading to other places. After 1660, there was a general tendency towards a monumental style and more "elevated" subjects, such as those drawn from mythological or literary sources. Towards the end of the 17th century, as though struck by a sudden complex about their provinciality, the Dutch public gradually drifted away from the genre scenes and small paintings of the previous decades. Vermeer, a typical exponent of the Dutch tradition, suffered as a result of this change in taste.

▼ Dominicus van Wijnen, *An Astrologer Observing the Autumn Equinox*, c.1680, Muzeum Narodowe, Warsaw. This allegorical work, classical in feel, met the demands of the art market.

▲ Gérard de Lairesse, *The Emperor Augustus Patronizing the Arts*, 1672, Muzeum Narodowe, Warsaw. An allegorical theme in the ancient manner would have been unthinkable a decade earlier.

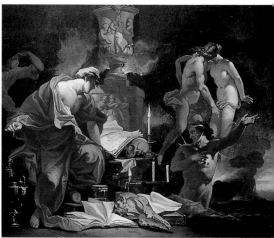

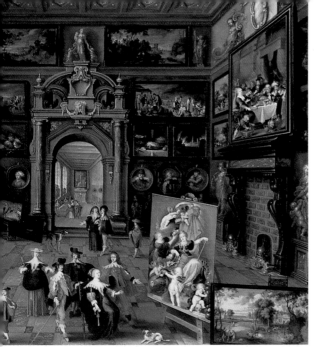

◄ Fans Francken II, *A Collector's Gallery*, Residenzagelerie, Salzburg. This painting captures the feel of wealthy collections of the Baroque period.

▼ Rembrandt, *The Jewish Bride*, 1667, Rijksmuseum, Amsterdam. Rembrandt was regarded as something of a heretic in painting, fully aware that he was going against the passing fashions of his day and allowing history to judge his achievement. His late works, rich and rough in texture, defy academic rules, which ordained smooth brushwork.

LIFE AND WORKS

The Artist's Studio: a legacy

I t is very difficult to single out a particular work in Vermeer's scant output as a cornerstone that could synthesize all the elements that make up his style. It is, however, very tempting to see *The Artist's Studio* as the key to unravelling the delicate mystery surrounding his work. This is a late painting, dating from after 1670 and revealing the advanced use of perspective that characterizes the later works. The artist in the painting is shown, in an unusual but appealing touch, with his back to the viewer, looking at the model from the same viewpoint as the viewer. The girl, striking a pose that suggests she is symbolizing a Muse, is surrounded by a series of objects that may be interpreted allegorically as a reference to the five senses. The map may be an allusion to the war between France and Holland and the constant threat hanging over the country's fragile boundaries. There is a quiet magic to the light, which glides along the wall, nestles among the folds of the map, and gently comes to rest on the beautiful girl.

▲ Rembrandt, *The Artist in his Studio*, 1628, Museum of Fine Arts, Boston. The young artist, alone and almost dwarfed by his easel, faces with a perplexed expression the large canvas, which reflects a luminous glow. As ever, Rembrandt underlines the practical, almost craftsmanlike aspect of his work.

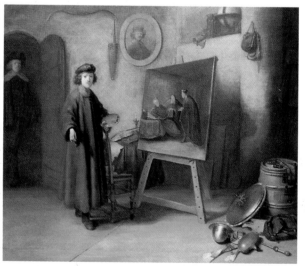

◄ Gerrit Dou, *Self-portrait with Easel*, c.1640, Private Collection. This painting by Dou, Rembrandt's first pupil, was clearly inspired by the master's work but places more emphasis on cleanliness, order, and sobriety. He could not resist the temptation of adding a "painting within a painting", showing us a nearly finished painting on the easel. This is a clever and skilful device, technically admirable but not particularly poetic in tone.

▼ Vermeer, *The Artist's Studio*, c.1665–1666 Kunsthistorisches Museum, Vienna. This moving painting was at the center of a bitter dispute between Vermeer's wife and mother-in-law just a few months after the artist's death. It seems inconceivable that such a beautiful work, which captures all Vermeer's harmonious style, should have aroused such strong feelings between mother and daughter. In the well-ordered, luminous room, a young woman poses in classical costume, as though she were a Muse from antiquity. The scene is governed by absolute silence, beauty, and contemplation.

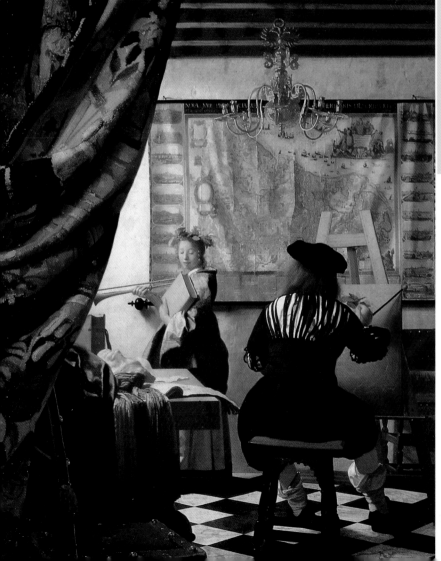

A sudden,
untimely death

The year 1675 was to be Vermeer's last. Although weighed down by his precarious financial situation (on July 20, the artist went to Amsterdam in order to borrow the considerable sum of 1,000 guilders) and increasingly concerned by the grim war with France, he continued to paint magnificent paintings: one of these, *The Artist's Studio*, would give rise to a complex series of events after his death. Vermeer died on December 13, 1675, and was buried in the Oude Kerk in Delft. The cause of his death is unknown. Catharina Bolnes, who was a year older than her husband, was left with no fewer than 11 children to feed, ten of them still minors. The situation was impossible from the start: as early as January 27, 1676, barely a month and a half after her bereavement, Catharina was forced to sell two of Vermeer's last paintings in order to settle a large debt (more than 617 guilders) owed to the baker Hendrick van Buyten. On February 10, in a spectacularly unfair transaction, the art dealer Jan Coelenbier paid her a mere 500 guilders for 26 canvases as security against one of the artist's debts. Catharina was left with just one painting by her husband: *The Artist's Studio*.

▲ Jacques Callot, *Macabre Allegory (Death Devouring Children)*, engraving. The French painter and engraver frequently returned to the theme of death, both allegorically and as a condemnation of the disasters brought about by the continual wars that raged throughout central Europe.

◄ Michiel and Pieter van Mierevelt, *The Anatomy Lesson of Doctor Willem van der Meer*, 1617, Museum het Prinsenhof, Delft. In the best Dutch tradition, which was also developed by Rembrandt, this macabre painting shows a public anatomical dissection carried out in Delft by a physician.

▶ Frans van Mieris, *Blowing Bubbles*, 1663, Mauritshuis, The Hague. This painting explicitly echoes the theme of the Goltzius engraving below. Here, too, the boy is blowing bubbles. Besides the transience of life, the work includes an allegorical reference to the risks of love, in the form of the half-withered sunflower in the foreground.

▼ Hendrick Goltzius, *Quis evadet? (Who Can Escape?)*, 1594, engraving. Late-Renaissance in inspiration, Goltzius' engravings, complete with sayings and proverbs, were widespread in Holland and constitute one of the fundamental elements in the country's culture during the 17th century. Here, an elegant putto leans on a skull and blows bubbles.

Blowing bubbles

One of the most popular and moving images used in Baroque art to symbolize the brevity of life and the transient nature of beauty was that of the child blowing bubbles. Vermeer's short life, which ended with his premature death at the age of just 43, can be seen to have been contained inside the fragility of such a bubble. Why Vermeer's work should have been forgotten for such a long time is one of the mysteries of the history of art, although it can partly be explained by the decline of Delft and, more generally, of Holland as a whole from 1700. Recent studies into Vermeer and his work, culminating with a memorable exhibition held in Washington, DC, and The Hague in 1996, have done much to eliminate some of the legendary and romantic hypotheses surrounding the artist's life.

The Allegory of Faith

This painting, which dates from 1675 and is possibly Vermeer's last work, is housed in the Metropolitan Museum of Art, New York. Although the figure and many details carry a symbolic meaning and the interpretative context is a doctrinal one, Vermeer still manages to make the scene convincing to us.

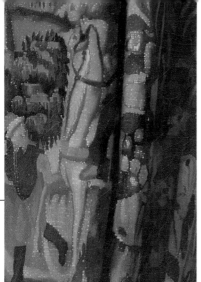

◀ The details, such as the tapestry parted to reveal the scene, are rendered with impressive skill. Openly Catholic in feel, the work may have been commissioned by a Catholic customer in Delft. The painting's first recorded owner, however, at the end of the 17th century, was the Protestant Herman van Swoll, Amsterdam's chief postmaster.

▼ The figure and the symbolic attributes are taken from Cesare Ripa's *Iconologia*, a manual of allegories. Vermeer blends colors, gestures, and objects from four different images of Faith described by Ripa. The serpent squashed by a stone symbolizes Evil defeated by Christ.

▶ The chalice placed next to the crucifix (instead of being held in the hand of Faith, as Ripa would require) gives the image a powerful Eucharistic significance, strengthening the specifically Catholic tendency of the whole allegory.

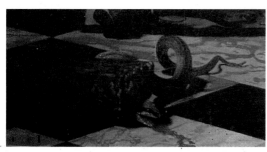

▶ Jacob Jordaens, *Crucifixion*, c.1620, Private Collection. Once again, Vermeer adds content to the scene by inserting a "painting within a painting". The picture in question, a respected work by the Antwerp artist Jordaens, is listed in the inventory of Vermeer's possessions drawn up after his death, as is the precious ebony crucifix shown next to the figure.

The misadventures of the widow Vermeer

The crisis that followed Vermeer's death was, sadly, a common enough one, but it was exacerbated by problems arising from a wider scenario (the war with France) and by particularly troublesome relatives (the artist's mother-in-law, Maria Thyns). In February 1676, Maria Thyns demanded the repayment of a debt owed by her deceased son-in-law. Catharina sought to placate her determined mother by offering her *The Artist's Studio*, and an inventory of the artist's chattels was drawn up. Twice Catharina appealed to the High Court at The Hague, pleading financial embarrassment and asking the court to impose an order on her mother forcing her to return the painting. Her pleas were granted. Meanwhile, Antonie van Leeuwenhoek, who was appointed the curator of Vermeer's estate and the executor of his will, went to great efforts to secure the restitution of the 26 paintings purchased by Jan Coelenbier as security against another debt. On February 5, Vermeer's paintings were put to public auction, but Maria Thyns challenged the restitution order on *The Artist's Studio* and withheld it from the auction. Once again, van Leeuwenhoek had to take legal action and, on March 15, the painting was put up for auction together with Vermeer's remaining possessions. Maria died in 1680 and Catharina in 1687.

▲ Jacob Backer, *Four Governors of the Amsterdam Orphanage*, 1634, Historisch Museum, Amsterdam. Although run with the best of intentions, orphanages rarely offered their charges a happy childhood.

◀ Vermeer, *A Lady Writing a Letter with her Maid*, c.1670, National Gallery of Ireland, Dublin. This painting, is a supreme example of Vermeer's psychological insight, with its hints as to the subtle relationship between the two women, its use of light, and the characteristic interior. It seems to anticipate the situation in which the artist's widow would all too frequently find herself, obliged to write letters pleading for leniency and financial assistance. The maid's gaze is drawn to the elegant, heavily leaded window.

▼ The careful maintenance of historically significant buildings in Holland, particularly those dating from the so-called Golden Age, offers us a glimpse into 17th-century interiors as they would have been in their day. This room in the Amsterdam Orphange includes furnishings and light fittings typical of those featured in Vermeer's interiors.

◀ Ferdinand Bol, *The Governors of the Amsterdam Leprosy Hospital*, 1649, Rijksmuseum, Amsterdam. This group of austere individuals have assembled to consider the plight of a little boy, presumably an orphan, who stands, intimidated, on the left.

The public's tastes change

During the 18th century, Vermeer's name and reputation were almost totally eclipsed. Delft fell into an inexplicable oblivion, as did Vermeer although his works were spared this fate. By tracing the tortuous histories of each individual painting, scholars have been able to show that in the 18th century, collectors fought over many of Vermeer's works and that the paintings continued to fetch high prices both at auction and in sales, even though most of them were erroneously attributed to other artists, such as Gabriel Metsu, Pieter de Hooch, and Frans van Mieris. A wall of silence, however, unquestionably fell over Vermeer for a long time, a phenomenon not uncommon in the history of art, but particularly acute in this case. The fact that he was so little known may be due in part to the changing taste of Dutch art customers, who had tired of nostalgic scenes showing happy days gone by and now looked for different subjects.

▼ Jan Ekels the Younger, *The Writer*, 1784, Rijksmuseum, Amsterdam. This painting recalls the intimate quality of Vermeer's work more than a century after his death.

▲ Tulips, the enduring symbol of Holland, are illustrated here in an 18th-century watercolor print. At this time, the nation was waning and searching for change.

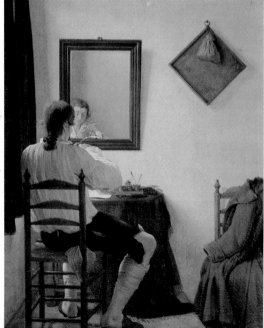

◀ Meindert Hobbema, *The Avenue, Middelharnis*, 1689, National Gallery, London. This is one of the last masterpieces of the Dutch 17th-century landscape school. Alongside the faultless perspectival structure and the faithful reproduction of detail, the painting also evokes an acknowledgment of melancholy and nostalgia.

▶ Cornelis Troost, *A Townhouse Garden* Rijksmuseum, Amsterdam. Paintings by the foremost Dutch artist of the 18th century usually portray places and situations similar to the subjects favored during the Golden Age. However, Troost's works are the most powerful evidence of the radical change that occurred in Holland at this time: the poetic simplicity of the 17th century is now replaced by the pursuit of Frenchified elegance.

◀ Cornelis Troost, *Friends were Beginning to Talk,* 1740, Mauritshuis, The Hague. This is part of a group of five paintings known as the "NELRI" series, after the titles' Latin initials. In their moral and social condemnation, they are very similar to the paintings produced at the same time by the English artist William Hogarth.

A final glory

The 19th century saw a clamorous rediscovery of Vermeer. The enthusiasm for the Dutch artist reached almost fanatical levels at the end of the century, thanks in part to the public's renewed interest in art in the form of Impressionism. There were some passionate disputes between American collectors, including illustrious figures such as J. Pierpont Morgan and Isabella Stewart Gardner, who offered staggeringly high prices for Vermeer's works and introduced important paintings into the United States: the series of Vermeer paintings housed in New York (the Frick Collection and the Metropolitan Museum of Art) and Washington, DC (National Gallery of Art) are unquestionably the most numerous and most prestigious. The critic Étienne-Joseph-Théophile Thoré, who was forced to adopt the German pseudonym Wilhelm Bürger, played an important role in the critical rediscovery of Vermeer and correctly attributed several of his works. Thoré-Bürger acquired many Vermeers for himself, and these were sold at a memorable auction held in Paris in 1892.

▼ The French writer Marcel Proust was responsible for the poetic rediscovery of Vermeer. His emotionally charged writings to mark the exhibition of Dutch painting held in Paris in 1921 remain one of the most famous texts of literary art appreciation of all time. Vermeer was studied by critics, and his work subjected to the most thorough scientific examination in all its aspects, but his real fame is the result of temporary exhibitions and the commentary provided by literary figures.

▲ A photograph of the art critic Thoré-Bürger taken from the catalogue to the auction of his collection, held in Paris in 1892.

◀ Of all 19th- and 20th-century artists, it was Pierre Bonnard who, perhaps influenced by Proust, was best able to recapture the tender intimacy of Vermeer's work. His favorite subjects are silent, contemplative girls.

▼ *The Lacemaker* continues to be one of Vermeer's most popular works. Besides the obvious tribute paid to the painting by Bonnard, it has often been recalled and referred to, even in films.

Van Meegeren's deception

The story of forgers and forgery is a fascinating facet of art history. Although his career was only brief, Han van Meegeren remains one of the world's most celebrated forgers. At the end of the 1930s, he exploited the vague, imperfect knowledge of Vermeer by presenting the art market with works portraying characteristically large figures, ostensibly from the artist's youthful period. Van Meegeren was astute enough to use old canvases and to opt for Vermeer's least-documented period, fooling all the experts. He was eventually unmasked.

◀ Han van Meegeren, *The Supper at Emmaus* 1937, Boymans-van Beuningen Museum, Rotterdam. Identified as a Vermeer by the director Abraham Bredius and the critic Dirk Hanema, this painting was bought in 1938, by the Rotterdam museum for the sum of 100,000 guilders. It was later proved to be a forgery by van Meegeren.

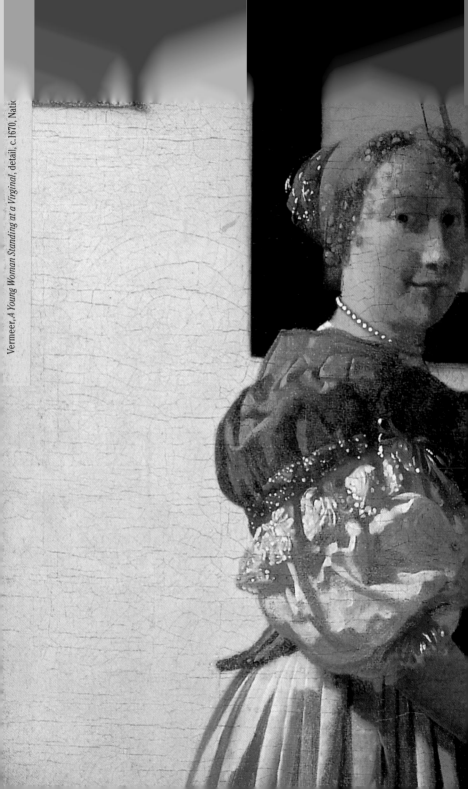

▲ Vermeer, *Diana and her Companions*, detail, c.1655, Mauritshuis, The Hague.

▶ The National Gallery, London.

▼ The Kunsthistorisches Museum, Vienna

▼ The main entrance to the Metropolitan Museum of Art, New York.

Note

All the names mentioned here are artists, intellectuals, politicians, and businessmen who had some connection with Vermeer, as well as painters who were contemporaries or active in the same places as Vermeer.

Bolnes, Catharina (1621 – Delft 1687), Vermeer's wife. A Catholic, she persuaded her husband to embrace this faith. Widowed with 11 children to support, she had to endure considerable financial hardship, pp. 22, 26, 122, 126.

Baburen, Dirck van (Utrecht c.1595 – 1624), Dutch painter. One of the foremost Caravaggesque artists in the Netherlands, he spent some time in Rome, where he was influenced by Caravaggio's expressive compositions, dramatic use of light, and plebeian figures. In Rome,

he painted mainly religious paintings but in Holland he preferred secular subjects, particularly concerts and musicians, p. 62.

Backer, Jacob Adriensz., (Harlingen 1608 – Amsterdam 1651), Dutch painter. A pupil and colleague of Rembrandt, he painted historical and hunting scenes, but is best-known for his portraits, p. 126.

Berckheyde, Gerrit (Haarlem 1638 – 1698), Dutch painter. A pupil of Frans Hals and of his brother Jacob, he painted mainly urban views of Amsterdam, p. 111.

Berckheyde, Jacob (Haarlem 1630 – 1693), Dutch painter of urban architecture, he introduced his younger brother Gerrit to the genre, p. 102.

Beyeren, Abraham Hendricksz. van (The Hague 1620/21 – Overschie 1690), Dutch painter. He specialized in still lifes in which opulent compositions and precious objects abound, rendered with skill and panache in the Baroque manner, p. 61.

Bol, Ferdinand (Dodrecht 1616 – Amsterdam 1680), Dutch painter and engraver. A pupil of

Rembrandt, his portraits enjoyed considerable success among the Amsterdam bourgeoisie, p. 127.

Bramer, Leonard (Delft 1596 – 1674), Dutch painter. Popular as a painter of historical scenes, he spent a long time in Rome, acquiring a troubled and expressive style, overlaid with touches borrowed from Rembrandt, pp. 22, 24.

Brueghel, Jan I, known as **Velvet Brueghel** (Brussels 1568 – Antwerp 1625), Flemish painter. The second son of Pieter the Elder, he owes his nickname to the smoothness of his palette. He specialized in still lifes and landscapes, often collaborating with other artists, painting landscapes, animals, and flowers for their joint works; for example, he painted floral garlands to decorate Madonnas and Holy Families by his close friend Rubens, pp. 18, 21.

Codde, Pieter Jacobsz., (Amsterdam 1599/1600 – 1678), Dutch painter. A pupil of Frans Hals, he was mainly active in

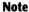 Jan Brueghel (Velvet Brueghel), *Vase of Flowers*, Pinacoteca Ambrosiana, Milan.

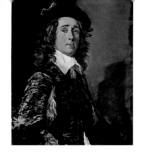

◄ Gerrit Dou, *The Young Mother*, Mauritshuis, The Hague.

◄ Frans Hals, *Portrait of Jasper Schade*, Narodni Galerie, Prague.

Amsterdam and painted social gatherings, interiors, and portraits, p. 60.

Dou, Gerrit (Leiden 1613 – 1675), Dutch painter. His elegant, diminutive paintings are characterized by their extremely precise and minutely detailed execution, pp. 74, 120.

Fabritius, Carel (Middenbeemster 1622 – Delft 1654), Dutch painter. A pupil of Rembrandt, his works, which are extremely few, constituted a fundamental source of reference for Vermeer in their illusionistic use of perspective, a predilection for thick fabrics, rich colors, and the overall freedom of their execution, pp. 14–15, 24.

Francken, Frans II the Younger (Antwerp 1581 – 1642), Flemish painter and the most famous of the Francken dynasty. He excelled in a variety of genres, specializing in small and medium-sized paintings, often showing biblical, mythological, and historical scenes crowded with figures, painted in a style

characterized by a fluidity of composition, the use of warm colors, and a delicate elegance of form, pp. 19, 119.

Hals, Frans (Antwerp 1581/85–Haarlem 1666), Dutch painter. He spent his entire, long career in Haarlem, where he painted the 17th-century Dutch bourgeoisie in vast patriotic compositions, individual portraits, and character studies, always aiming for a lifelike rendering of the sitter's facial likeness and physique. His highly original palette, powerful touch, and the spontaneity of his sitters' poses and expressions enabled him vividly to capture the presence and personality of the people he painted and made his portraits unforgettable, pp. 12, 22, 24, 48, 54, 60, 72.

Helst, Bartholomaeus van der (Haarlem 1613 – Amsterdam 1670), Dutch painter. Almost exclusively a portrait painter, he produced some of the most typical guild paintings of the Dutch school, known as *Schutter* and *Regentenstukken*, p. 55.

Heyden, Jan van der (Gorinchem 1637 – Amsterdam 1712), Dutch painter. He specialized in urban scenes, particularly views of Amsterdam,

which he executed in minute detail. He also painted a number of still lifes and interior scenes, which have a highly realistic feel, pp. 56, 105.

Honthorst, Gerrit van (Utrecht 1590 – 1656), Dutch painter. After a period spent in Rome, he became one of the main artists to introduce the new style and mood of Caravaggio's work to Utrecht and the northern Low Countries. He was known as "Gerard of the Nocturnes" because of the contrast between light and shade that characterizes many of his candle-lit works, pp. 16, 111.

Hooch, Pieter de (Rotterdam 1629 – after 1684), Dutch painter. He favored subjects connected with domestic life and interior scenes, which he interpreted with original volumes, forms, and colors, weaving subtle and poetic links between the human figures and the objects surrounding it. He is regarded as one of the best Dutch intimist painters after Vermeer, pp. 11, 41, 60, 68, 74–75, 86, 109, 113, 128.

Horemans, Jan Josef I known as **the Elder** or **The Obscure** Antwerp 1682 – 1759), Flemish painter. His popular paintings,

◄ Gerrit van Honthorst, *The Death of Seneca*, Central Museum, Utrecht.

▶ Jacob Jordaens,
The Rape of Europa,
Staatliche Museen,
Berlin.

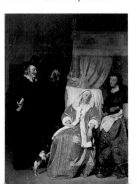

which are anecdotal in character, are typical of a trend that was widespread in 18th-century Flemish genre painting, p. 31.

Huygens, Christiaan (The Hague 1629 – 1695), Dutch physicist, mathematician, and astronomer, he proved the fundamental laws of optics, p. 92.

Huygens, Constantijn (The Hague 1596 – 1687), Dutch diplomat. Secretary to Frederick Henry, Prince of Orange, he had a wide knowledge of the arts and sciences and was also a patron of the arts, pp. 92–93, 111.

Jansz., Reynier (c.1591 – Delft 1652), Vermeer's father. His family, who were originally from Flanders, had moved to Delft in 1597 and here Reynier worked as a weaver before becoming an inn-keeper and art dealer, p. 16.

Jordaens, Jacob Antwerp 1593-1678), Flemish painter. His eclectic training, influenced by Roman classicism, Michelangelo, Caravaggio, and late 16th-century Venetian painting led him to develop a showy, expressive style of painting, characterized by vibrant colors and violent contrasts between light and shade. He translated religious

and mythological themes into an earthly, bourgeois context, pp. 110, 125.

Kalf, Willem (Rotterdam 1619 – Amsterdam 1693), Dutch painter, regarded as the founding father of the Amsterdam school of still-life painting. His repertoire is based on the juxtaposition of goldwork objects, glasses, ceramics, porcelain, and other rare artefacts arranged on luxurious fabrics in deep colors, all rendered with a warm, precious style pp. 54, 82.

Lairesse, Gérard de (Liège 1640 – Amsterdam 1711), Dutch painter. A pupil of Rembrandt, he was one of the main artists working in Liège, an artistic center in which the classical current of French and Roman origin predominated and would from 1660 create a crisis for the Flemish Baroque tendency derived from Rubens and Rembrandt himself, pp. 51, 118.

Leeuwenhoek, Antonie van (Delft 1632 – 1723), Dutch microscope maker, he was appointed curator of Vermeer's estate on the artist's death. He manufactured more than 500 almost perfect lenses, which he used to correctly interpret a number of natural phenomena

that could now be viewed for the first time, pp. 104, 105, 126.

Leyster, Judith (Haarlem 1609 – 1660), Dutch painter. A pupil of Frans Hals and wife of the painter Jan Miense Molenaer, she produced genre scenes and musical subjects, pp. 80, 85.

Lucasvan Leyden (Leiden c.1490 – 1533), Dutch painter and engraver. A prolific engraver, his production of prints on copper and wood is among the most noteworthy and influential of the 16th century. He was also a skilled painter: his genre scenes make him one of the first realist painters, in the modern sense of the term, p. 17.

Maes, Nicolaes (Dordrecht 1634 – Amsterdam 1693), Dutch painter. Applying his teacher Rembrandt's example with originality and combining it with elements drawn from Rubens and van Dyck, he specialized in genre painting and was a successful portrait painter, pp. 12, 90.

◀ Gabriel Metsu,
The Physician's Visit,
The State Hermitage
Museum, St Petersburg.

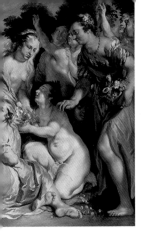

▶ Adriaan van Ostade, *Peasant in a Tavern*, Thyssen-Bornemisza Collection, Madrid.

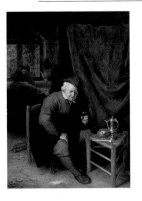

to showing off his painterly virtuosity. In some of his best paintings he comes close to Vermeer and Ter Borch, pp. 31, 43, 128.

Man, Cornelis de (Delft 1621 – 1706), Dutch painter. His paintings, stylistically similar to those of Pieter de Hooch and Vermeer, include portraits, church views, and interiors, p. 102.

Meegeren, Han Antonius van (Deventer 1889 – 1947), Dutch painter. A master forger, he produced a number of paintings in the Vermeer style, including *Supper at Emmaus*. With this he fooled critics and collectors alike and opened the floodgates during the period between the two World Wars for a whole wave of discoveries of presumed masterpieces by the Delft artist that were later proved to be fakes, p. 131.

Metsu, Gabriel (Leiden 1629 – Amsterdam 1667), Dutch painter. His work displays a wide variety of themes and styles. He often painted figures within the framework of a niche, as well as precious, delicately rendered genre scenes and poetic still lifes that were sometimes a pretext

Mieris van, Frans, the Elder (Leiden 1635 – 1681), Dutch painter. He produced portraits and genre scenes in the style of his teacher Gerrit Dou, minutely detailed and harmonious in color, pp. 68, 70, 78, 86, 123, 128.

Molenaer, Jan Miense (Haarlem c.1610 c. – 1668), Dutch painter. His small paintings, which show interiors, genre scenes, and family groups reveal the influence of Frans Hals and Rembrandt, p. 103.

Nassau-Siegen, John Maurice, Count of (Dillenburg 1604 – Berg en Dal, Gelderland, 1679), Dutch soldier, colonialist, and politician and governor general of the Dutch colony in Brazil between 1636 and 1644. He built the Mauritshuis in The Hague, which was designed by Pieter Post, pp. 110, 111.

Netscher, Caspar (Heidelberg 1639 or Prague 1635/36 – The Hague 1684), Dutch painter. Active in Ter Borch's studio, he was one of the most famous

portrait painters in Europe thanks to the elegance of his small paintings, p. 113.

Orange-Nassau, William I of, known as **The Silent** (Dillenburg, Nassau 1533 – Delft 1584), governor of Holland, Zetland, and Utrecht from 1559 to 1584. He fought against Spain and led a number of popular insurrections, resulting in his authority being acknowledged by the rebel provinces. On his death, the United Provinces' fight for independence continued, under the léadership of his son Maurice, pp. 8, 9, 10, 16, 37, 102.

Ostade, Adriaan van (Haarlem 1610 – 1684), Dutch painter. Active in Haarlem, he produced a number of peasant scenes, mostly small in dimension. He was much admired by his fellow-artists, p. 13.

Pietersz., Pieter known as **Jonge Lange Pier** (Antwerp 1540/41– Amsterdam 1603), Dutch painter. Active in Haarlem and

► Michiel Sweerts,
Roman Fighters,
Staatliche Kunsthalle,
Karlsruhe.

Amsterdam, he painted biblical subjects and realistic portraits, p. 37.

Poel, Egbert Lievensz. van der (Delft 1621– Rotterdam 1664), Dutch painter. He painted country landscapes, interiors, market scenes, and numerous depictions of the explosion of the gunpowder magazine that devastated the city of Delft in 1654, turning it into a veritable genre scene subject, p. 59.

Proust, Marcel (Paris 1871–1922), French writer. He contributed to the critical reassessment of Vermeer's work, both in essays on painting and in his novel *In Search of Time Lost*, in which the character Swann names Vermeer as his favorite artist, mirroring Proust's own view, p. 130.

Quellinus, Erasmus (Antwerp 1607– 1678), Dutch painter. Official painter to the city of Antwerp after the death of Rubens, he produced numerous mythological and religious

paintings as well as battle scenes. He also worked for still life and flower painting artists, executing the human figures in their paintings of garlands, p. 21.

Rembrandt, Harmensz. van Rijn known as (1606–1669), Dutch painter. One of the most innovative and complex figures in the entire history of art, an artist of extraordinary talent, he favored both historical scenes and portraits, executing these as a free study in expression and as a form of autobiographical record, pp. 13, 16, 23, 24, 29, 34–35, 42, 43, 48, 49, 50, 55, 56, 61, 62, 70, 71, 80, 91, 92, 93, 114, 119, 120.

Rubens, Peter Paul (Siegen 1577 — Antwerp 1640), Flemish painter. One of the major artists in 17th-century Europe, his paintings capture the Baroque style, with a continuous and illusory vision of space, animated by powerfully emotional light effects, pp. 21, 27.

Ruysdael, Jacob van (Leiden 1628/29 – Amsterdam 1682), Dutch painter. He is famous for his views and landscapes, which are rendered with minute precision and sensitivity in the naturalistic details and faithful to the topography of the places depicted, p. 57.

Saenredam, Pieter (Assendelft 1597 – Haarlem 1665), Dutch painter. Famous for his rigorous, scientifically accurate reproduction of historically significant religious and monumental buildings. His austere, formal rigor, the clarity of the atmosphere, and his painstaking precision give his sober and objective views an abstract feel, pp. 12, 40, 56.

Steen, Jan (Leiden 1626 – 1679), Dutch painter. He painted subjects from everyday life, populist, or libertine scenes, adding a personal touch of humor, sometimes satirical and moralizing, to what was essentially a traditional genre, pp. 10, 21, 22, 39, 41, 51, 68, 69, 72–73, 81, 86, 91, 107, 115.

Stosskopff, Sebastian (Strasbourg 1597 – Idstein 1657), German painter. His work consists almost exclusively of still lifes and is derived from Flemish and Dutch painting, reinforced

◄ Peter Paul Rubens,
The Three Graces,
1636–1638, Museo
del Prado, Madrid.

thanks to his direct contact with Italy by Caravaggesque overtones, p. 87.

Sweerts, Michiel (Brussels 1624 – Goa 1664), Flemish painter. In Rome, towards the middle of the century, he was part of the group of foreign artists who gravitated around the *bamboccianti* artists. Even after his return to Brussels he remained faithful to a style and themes that were Caravaggesque in inspiration, producing intensely poetic, grave, and melancholy works, pp. 30, 42.

Teniers, David II the Younger (Antwerp 1610 – Brussels 1690), Dutch painter. The son and pupil of David I, he was famous as a genre painter but also painted portraits, landscapes, and historical scenes, producing thousands of works, pp. 10, 18, 19.

Ter Borch, Gerard (Zwolle 1617 – Deventer 1681), Dutch painter. A gifted portrait painter,

he distinguished himself in the portrayal of genre scenes drawn from bourgeois life, rendered in a subtle and elegant manner, achieving a successful balance between the requirements of psychological observation and the poetry of objects and the space surrounding them, pp. 24–25, 37, 68, 86, 91.

Thoré, Étienne Joseph-Théophile (1807–1869), French man of letters and politician. Forced into exile after the 1848 Revolution, he devoted himself to art criticism, writing under the pseudonym of Wilhelm Bürger and concentrating on the rediscovery of Vermeer, p. 130.

Thyns, Maria (c.1593 – Delft 1680), Vermeer's mother-in-law, pp. 22, 70, 126.

Venne, Adriaen Pietersz. van de (Delft 1589 – The Hague 1662), Dutch painter. His works, which abound with realistic details treated with a gentle humor, carry on the tradition of Bosch and Pieter Brueghel in their illustration of proverbs. He was also a fine portait painter and engraver, p. 36.

Vermeer, Geertruijt, (Delft 1620– 1670), Vermeer's sister, pp. 70, 102.

Verspronck, Johannes (Haarlem 1597 – 1662), Dutch painter. He painted portraits that soon displayed liberation from the influence of Frans Hals, his teacher, achieving his own individual elegance of execution, with delicate, lightly applied shading on monochrome, transparent backgrounds, p. 48.

Witte, Emanuel de (Alkmaar 1615 or 1617 – Amsterdam 1691 or 1692), Dutch painter specializing in views of church interiors. The churches that feature in his paintings, Catholic and Protestant alike, are treated imaginatively, borrowing elements from several different buildings and styles, and are generally shown while a service is taking place or when they are busy with worshippers, p. 12.

▶ David Teniers the Younger, *Peasant Dance*, Museo del Prado, Madrid.

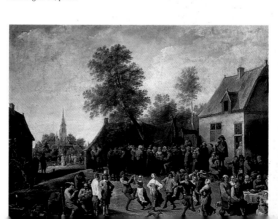

▶ Vermeer, *View of Delft*, 1660–1661, Mauritshuis, The Hague.

1632 Johannes Vermeer is born in Delft, the son of Reynier Janszoon, an inn-keeper who also worked as an art dealer and was a member of the guild of painters in Delft.

1652 On Reynier's death, Vermeer carries on the work his father had begun, managing the inn and dealing in works of art.

1653 He marries Catharina Bolnes, a Catholic, and clashes frequently with his mother-in-law, Maria Thyns. Witnesses to the wedding include the painter

Leonard Bramer. The 21-year-old Vermeer is recorded as being a member of the painters' guild at this time.

1654 The explosion of the Delft gunpowder magazine occurs, killing the artist Carel Fabritius, who may have been a stylistic point of reference for the young Vermeer at the beginning of his career. Vermeer's artistic activity begins during this period, with his early religious or mythological paintings.

1656 The year in which Vermeer paints *The Procuress*. Only two of Vermeer's works are dated, which makes it difficult to work out the sequence of his paintings with any degree of accuracy. Works that can definitively be attributed to him, however, number only about 40.

1662–63 The artist holds positions in the painter's guild but continues his work as an inn-keeper and art dealer.

1664 He is recorded as being a member of the Delft civic militia.

1668 The year in which the second dated painting, *The Astronomer*, was executed, now housed in Paris.

1672 He is summoned to the Orange court at The Hague in

▲ Vermeer, *Christ in the House of Martha and Mary*, 1655, National Gallery of Scotland, Edinburgh.

▶ Vermeer, *Woman and Two Men*, 1659–1660.

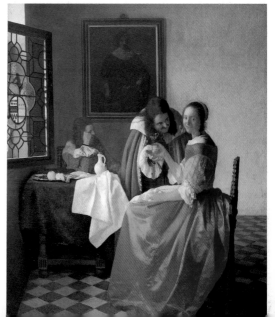

▼ Vermeer, *The Artist's Studio*, c.1672, Kunsthistorisches Museum, Vienna.

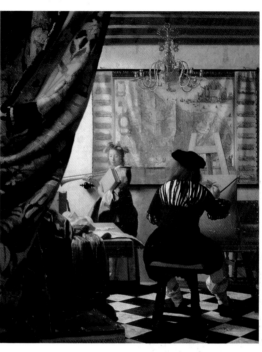

1675 He dies suddenly, aged 43, leaving no fewer than 11 children and considerable debts. The scientist Antonie van Leeuwenhoek is named his executor. A year after her husband's death, Vermeer's widow is obliged to sell the last painting she has left to settle a debt she owes the baker.

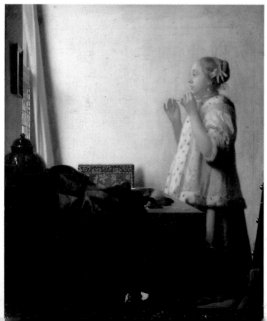

◀ Vermeer, *Woman with a Pearl Necklace*, 1665, Staatliche Museen, Berlin.

A DK PUBLISHING BOOK
www.dk.com

TRANSLATOR
Anna Bennett

DESIGN ASSISTANCE
Rowena Alsey

EDITORS
Louise Candlish, Jo Marceau

MANAGING EDITOR
Anna Kruger

Series of monographs
edited by Stefano Peccatori and Stefano Zuffi

Text by Stefano Zuffi

PICTURE SOURCES
Archivio Electa; Archiv für Kunst und Geschichte, Berlin

Elemond Editori Associati wishes to thank all those museums and
photographic libraries who have kindly supplied pictures, and would be pleased
to hear from copyright holders in the event of uncredited picture sources.

Project created in conjunction with
La Biblioteca editrice s.r.l., Milan

First published in the United States in 1999 by DK Publishing Inc.
95 Madison Avenue, New York, New York 10016

Vermeer, Joannnes, 1632–1675.
 [Vermeer. English]
 Vermeer. -- 1st American ed.
 p. cm. -- (ArtBook)
 ISBN (invalid) 0-7849-4850-5 (alk. paper)
 1. Vermeer, Johannes, 1632–1675 Catalogs. I. Title.
II. Series: ArtBook (Dorling Kindersley Limited)
ND653.V5A4 1999
759.9492--dc21 99-36728
[B] CIP

First published in Great Britain in 1999
by Dorling Kindersley Limited,
9 Henrietta Street, London WC2E 8PS

A CIP catalogue record of this book is available from the British Library.

ISBN 0-7513-0778-5

2 4 6 8 10 9 7 5 3 1

Printed by Elemond s.p.a. at Martellago (Venice)